IMAGES
of America

FLOYD
COUNTY

IMAGES
of America

FLOYD
COUNTY

Bobby G. McElwee

ARCADIA
PUBLISHING

Published by Arcadia Publishing
Charleston, South Carolina

Printed in the United States of America

Library of Congress Catalog Card Number: 98-87451

For all general information contact Arcadia Publishing at:
Telephone 843-853-2070
Fax 843-853-0044
E-mail sales@arcadiapublishing.com
For customer service and orders:
Toll-Free 1-888-313-2665

Visit us on the Internet at www.arcadiapublishing.com

CONTENTS

ACKNOWLEDGMENTS

Many people contributed to the contents of this book. I have listed some of them below. I apologize here to those I may have failed to identify. Those who know me understand the difficulty I have had finding time to do this book. Thanks to Brentz Turner for contributing the largest amount of postcards; Bernice Couey Biship Anderson for assistance with Shannon, Hermitage, Silver Creek, Pinson, and Seney; Dr. C.J. Wyatt for assistance with Rome, Desoto, police departments, and factories; Emmalee Highnote for help on Cave Spring; Robert Rakestraw for Indian sketches; Chip Tilly for East Rome and the railroads; Jean Christian for Coosa and area churches; Scott Breithautt for Oakhill and the Martha Berry Museum; Chuck Douglas for Major Ridge's Ferry and Chieftain's Museum; Dr. Alice Taylor-Colbert for Shorter College and Museum; Floyd, Chattooga, and Polk Counties Medical Alliance for medical information; Genelle Shaw for the Shaw House on Jackson Chapel Road; Russell McClanahan for Hillsboro and South Rome; Herman G. House for photo of W. House on street sweeper; Shirley for the Wax community photograph; Wallis Lloyd for Coosa information; Mary Francis McArver, also for Coosa information; and Lois Holbrook for assistance with the Old Coosa Post Office.

INTRODUCTION

Man is known to have inhabited the area around what is currently Rome, Georgia, for more than nine thousand years. This is confirmed by archaeological digs and local artifacts. As any history prior to 1540 would be speculative, this book begins in that year, with the arrival of the Spanish explorer, Hernando DeSoto. The first written word of local history comes from this expedition. When DeSoto arrived, the Mississippian Era was in its last stage, and from it Creek culture was evolving. Other Spaniards followed and some settled in this area. In the early 1600s, French settlers began to arrive. They blended in with the local inhabitants and began trading furs and other goods with the Creek Indians. The Spanish and French had little trouble with the Indians, as they preferred the advantages of trade with the Native Americans over outright dominance.

In the 1660s, Scottish traders began to enter the Creek Nation. They were the first Europeans to actually live with the Indians. Many of them took Creek wives, settled down, raised families, and became members of the tribe. Today many Native Americans have the last name of their Scottish ancestors. Around 1670, the Scottish began trading rifles and pistols to the Indians, and by 1700 most of the native nations in the southeast sported firearms.

Relations between French and English had been marked for centuries by hostility and warfare, and discord continued in the struggle to settle America. The two European powers soon had the Indian nations facing off against each other. In 1725, the Creek and Cherokee entered into a war that lasted for 30 years. This war ended with the Creek tribe defeated, leaving what is now northwest Georgia and northeast Alabama as part of the Cherokee Nation.

In 1802, the United States purchased from Georgia all claimed lands west of the current Alabama-Georgia line. Alabama, Mississippi, and Louisiana were formed from what had been a part of Georgia. The third stipulation of the purchase agreement stated, "The United States shall remove all Indians from the State of Georgia." In 1831, Governor Lumpkin of Georgia appointed surveyors to map the Cherokee lands. In 1832, Georgia began a land lottery giving away the Cherokee lands, and by an act of its legislature founded Floyd County.

Floyd County was named for General Floyd who had fought with Andrew Jackson and the Cherokee against the Creek at the Battle of Horseshoe Bend. Many people of European descent already lived in the area. The community of Livingston was named as the county seat in 1832. Rome was founded in 1834 and the county seat was moved from Livingston to Rome.

In 1832, a court case involving the Cherokee made its way to the Supreme Court. The court ruled in favor of the Cherokee, and Chief Justice John Marshall wrote in the majority decision, "neither the State of Georgia nor the United States of America have any rights over the sovereign nation of the Cherokee." President Jackson chose to ignore the court's decision and sent General Winfield Scott south with orders to relocate all Indians to Oklahoma. This

is the only time in American history when a U.S. president acted against a decision by the U.S. Supreme Court.

Many towns once large enough to have a post office, town hall, and railroad station exist today only in photographs and historic records. Such examples are Chubbtown, Chulio, Crystal Springs, Early, Hammon Mills, Hermitage, Desoto, East Rome, Forestville, Hillsboro (later South Rome), Livingston, Nannie (later Pinson), Ridge Valley, Seney, Thomas Mills, Wax, and Vann's Valley. Perhaps there were more. References to those listed were found in official records.

Some early communities still flourish today. Examples are Coosa, Lindale, Shannon, and Silver Creek. Coosa was originally an Indian village. Inland Container and Georgia Power are two of the largest employers there today. Lindale is home to Lindale Manufacturing Company, one of the largest employers in the county. Shannon is home to several major manufacturing plants employing thousands of workers, and Silvercreek is a popular residential area. Each of these communities still has a post office and area businesses. Cave Spring and Rome are currently the only incorporated towns in the county. Many European descendants settled the Cave Spring area in the early 1800s. They blended well with the Cherokee who were there.

There is a legendary story told about the founding of Rome, Georgia. Two lawyers on the way to court in Livingston stopped to rest at a spring. They were joined by another man and the three agreed the area was a good place for a town. Thus Rome came to be. Rome fast became the industrial hub, not only of Floyd County, but of northwest Georgia. Individuals and companies recognized the economic potential of Rome's location on the rivers and at the approximate center of the county. Its commercial and residential areas rapidly outpaced other nearby towns, and within a short time Rome had the largest population of any town in the county.

The three rivers that run through Floyd County played an important role in the development of the area's economy. At first, riverboats carried lumber, indigo, wheat, corn, and later cotton, down the river to Mobile. Commercial riverboats operated between 1845 and 1912. Ferries once owned by Native Americans were kept in service, with some of them operating into the 1950s. These allowed travel across the rivers and connected the Georgia roads to those in Tennessee and northern Alabama.

The people of this area have answered their country's call to arms in many wars. Monuments throughout Rome testify to this. None, however, affected them nearly as much as the War Between the States.

Agriculture, major floods, Rome's first water system, churches, early fire departments, schools, colleges, and the forming of a medical community recognized as one of the finest in the world are all touched upon in this book.

Floyd County has five museums which preserve and protect the history of this area: Oak Hill at Berry College; the Chieftans, once home of Cherokee Major Ridge; the Clock Tower, Rome's first city water system; the Museum at Shorter College; and the Rome Area History Museum, which covers area history from 1540 through the present. Three other museums are currently being planned for Cave Spring, Darlington School, and Hermitage. Eight museums will make Floyd County truly unique among counties of relative size.

One

AREA'S EARLY
INHABITANTS

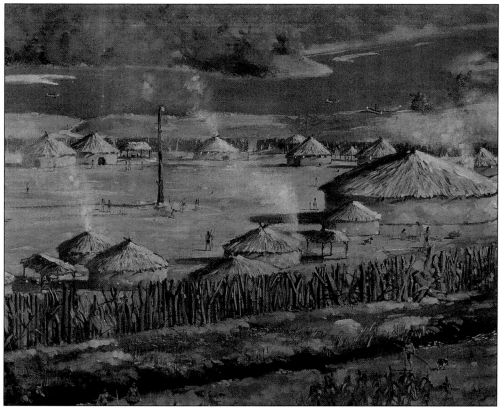

Sixteenth-century area residents constructed their homes from wood, straw, and clay. They were a social society living in towns surrounded by a high stockade-type wall for protection from wild animals. They were hunters, fishermen, and farmers. Their staple crops consisted of corn, beans, squash, sunflowers, and gourds. Many villages were located within what is now Floyd County, Georgia. The King Site is the best known of these. One of the published routes of Spanish explorer Hernando DeSoto's expedition shows him visiting this village.

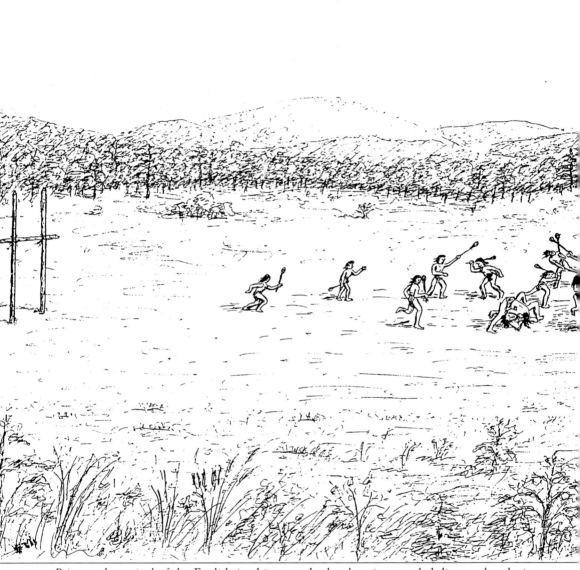

Prior to the arrival of the English in this area, the local nations settled disputes by playing a ball game that they called anesta, which means a little war. This was a very civilized method of preventing a real war. The object of the game was to get the leather ball through the goal

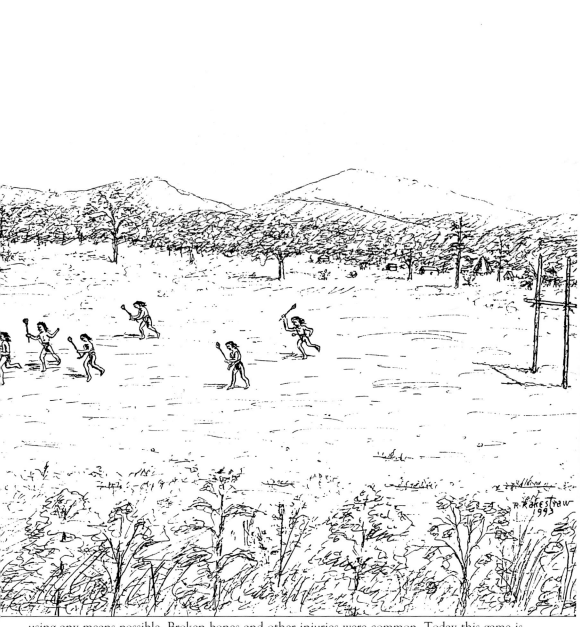

using any means possible. Broken bones and other injuries were common. Today this game is known as Lacrosse.

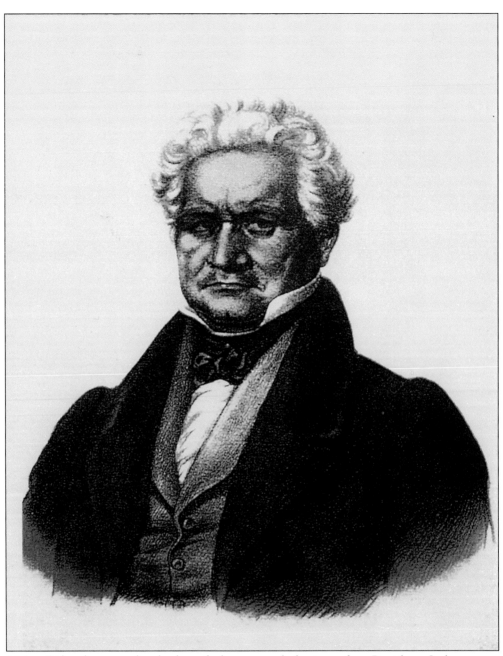

Major Ridge became the leader of the removal faction after President Jackson sent Gen. Winfield Scott to force the Cherokee to move west or face annihilation. The Ridge family came to know that the only way their nation could survive was by removal. Eighteen family members were the only ones to sign the treaty which the United States government used to send the entire Cherokee Nation westward. Major Ridge's home is today a museum in Floyd County.

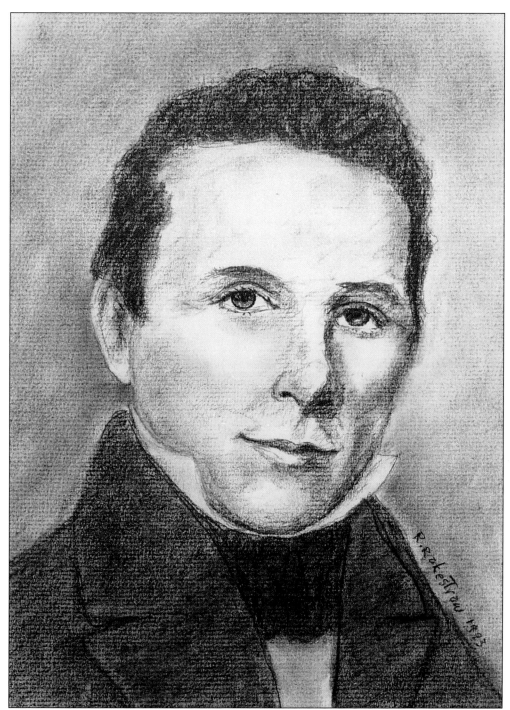

Cherokee Principal Chief John Ross held that title prior to, during, and after their removal west. Although only one eighth Cherokee by blood, he was full Cherokee at heart. He lobbied Washington continuously in support of his people and against the forced takeover of their lands. His home was located approximately 200 yards north of the mouth of the Coosa River and 200 yards west of the Oostanaula.

John Ross came home from Washington and found his wife, Quatie, and their children waiting in a storeroom. Georgia had given their home and the rest of the Cherokee lands away in a land lottery. On the Trail Where We Cried, Quatie Ross gave her only blanket to a sick child. She then caught pneumonia and died. She is buried somewhere along the trail, as are more than two thousand others.

John Ridge was the son of Major Ridge. He, his father, and his first cousin Alizia Boudinot were great orators and spoke across the northern United States asking support for the Cherokee cause. As the author of a Cherokee law against removal, John Ridge knew he and his family would die if they signed the Removal Treaty. The Ridge family chose to give their lives that the Cherokee people, as a whole, might survive.

John and Sara Northup Ridge built their home in Floyd County and named it Running Water. They owned a plantation of 360 acres. The Ridges were as well off as their neighbors of European descent. Running Water still stands today and is occupied by a caring family. This family made a successful stand against it being torn down for a Rome bypass in the 1980s.

Two

ONCE TOWNS NOW
ONLY COMMUNITIES

Floyd County was named for General Floyd, who had fought with Andrew Jackson. Livingston was named as the county seat in 1832. A two-room courthouse, a Methodist church, a one-room schoolhouse, and scattered residences made up the town. Livingston was located on what is today Highway 100, about 2 miles south of the Coosa River. All that is left of the original town is the cemetery.

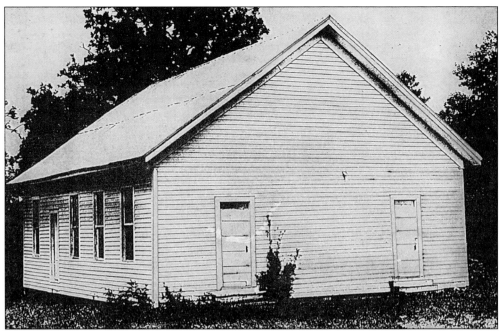

Religion was very important to early settlers. The Methodist church at Livingston was organized in 1832. Construction was completed on the church building in 1833. Notice the two doors. One is for men and the other is for women. This was common practice during this time period. The original church building has been replaced by a more modern brick structure. The Reverend Warren Jones is the current minister, as well as the area historian.

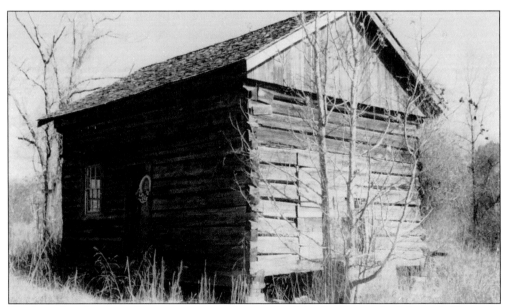

The log cabin shown in this picture is a good example of the first houses built by early European settlers. This one is located approximately 0.5 mile north of the original town of Livingston. Its original builder is unknown. In 1864, Colonel Arthur Erin moved his wife, Evelina, and their children into this cabin. Mrs. George Evans Avery is a direct descendant of Col. Erwin.

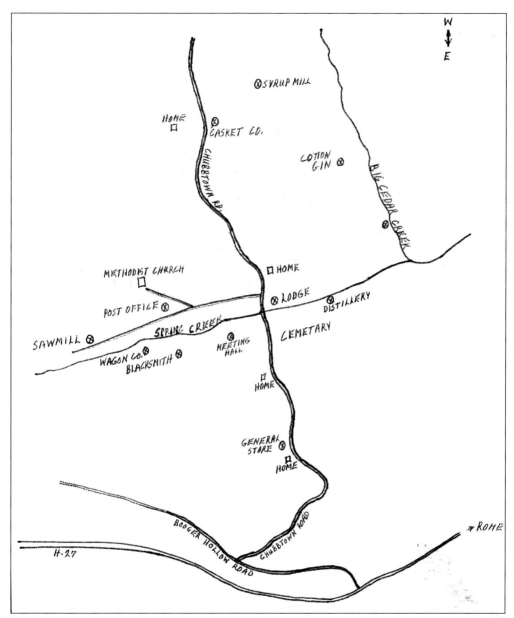

Chubbtown was established by the Chubb family (free blacks) in 1864, when Henry Chubb purchased 120 acres in south Floyd County. There were mills, a blacksmith shop, and a general store. There was also a church, lodge, post office, and several nice homes within its limits. Farmers of all races brought their products to Chubbtown's mills for processing. Records show that the Chubbs were well respected by their Caucasian neighbors, with no racial difficulties recorded.

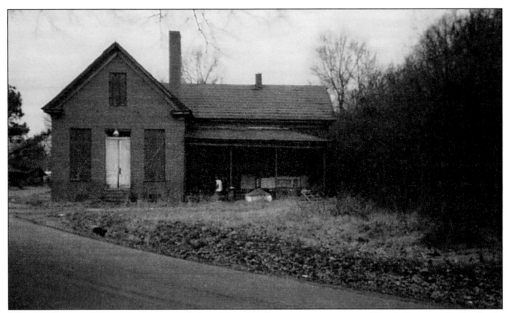

This building at Hermitage is one of the oldest brick store structures in Floyd County. It was built in the 1830s and used as a general store/post office until 1949. Located where a road from Gordon County joined a road between Bartow and Floyd Counties, it was convenient to residents of all three counties. As other roads were built, less traffic came its way. Mrs. Miriam Watters Rush was Hermitage's last postmaster.

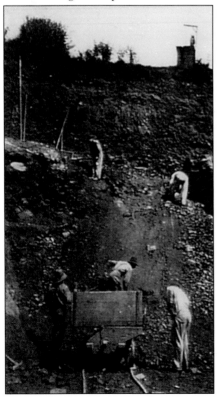

Mr. James Holland was digging a water well and noticed some "odd rocks." He had discovered bauxite on his property. The year was 1887, and the place was Hermitage. Bauxite was at that time used in manufacturing aluminum. Notice the well on the top of the hill above the workers. The area which was mined is today called the colons, and is potted with small lakes where springs have filled the cavities.

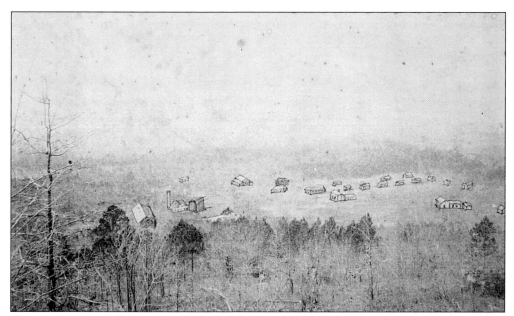

The community of Hermitage was one of the first towns in Floyd County. It was located on two of the most traveled roads in the area. At first, the principal industry was farming, and later mining began. This was a thriving village until an easier method of producing aluminum was discovered in another state, and bauxite was in less demand. As newer, better roads were constructed elsewhere, Hermitage became more isolated and slowly dissolved as a town.

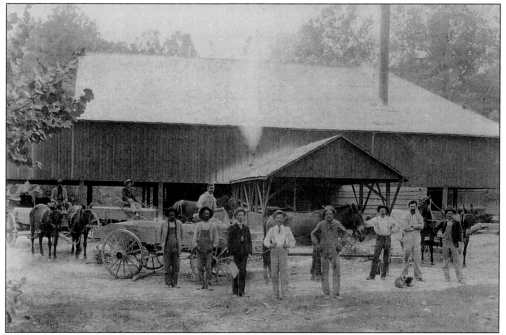

This crew is in front of the main buildings of Holland Hill Mines. Mr. Allen Murchison (grandfather of Jeanettee Milner Treadaway and Terry Murchison) is pictured here (third from right). Mr. Tom Watters is also shown (second from right). He was the grandfather of Thad Rush, Ann Barron, and John Rush. The rest of the crew have not, as yet, been identified.

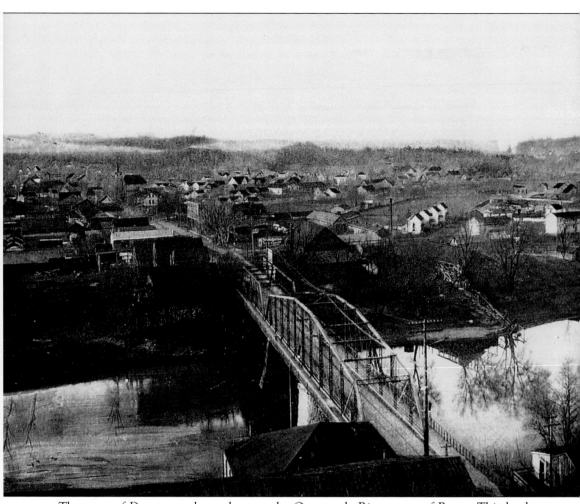

The town of Desoto was located across the Oostanaula River, west of Rome. This land was owned by Cherokee Principal Chief John Ross, prior to the Cherokee Land Lottery. Desoto became the 4th Ward of Rome in 1883. Most of this area was heavily affected by the floods until the levees were built in 1939.

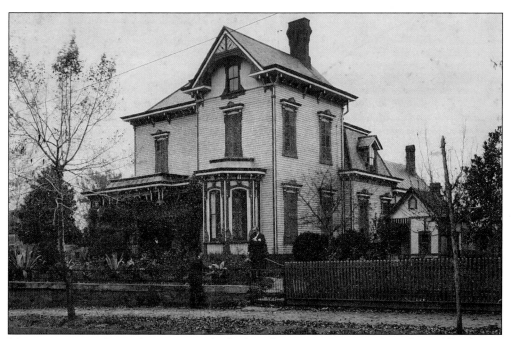

Many prominent Rome businessmen built their homes in Desoto. The Glover house is an example. Mr. Glover was involved in the establishment and operation of several successful ventures. He also had buildings constructed on and off of Broad Street in Rome.

The Baptist church in Desoto was built on a lot donated by J.A. Glover, in 1881. Colonel Alford was a major financial supporter for its construction. The Reverend L.R. Gwaltney was the first pastor. His tenure began April 1, 1883. The first deacons were J.A. Glover, William A. Wright, T.M. Drennon, and H.A.J. Beard.

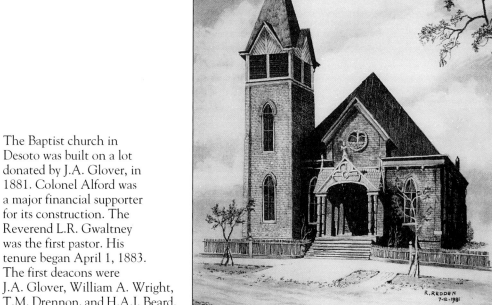

East Rome was incorporated as a town in 1883. The town was without official fire protection until 1905 when the Etowah Hose Company was formed. The fire station was located on what is today East 2nd Avenue in Rome. It served the area until 1962. F.H. Moore, Will Head, G.C. McCain, John Roupec, and Harry Wyatt were members of the original company.

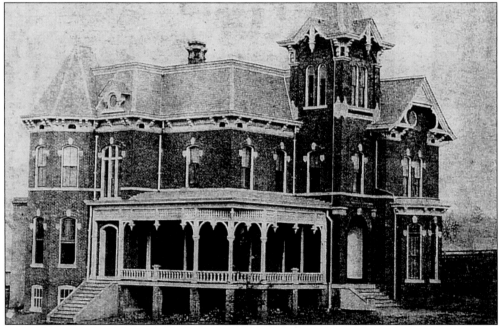

In 1879, stately Rio Vista was built by J. Lindsey Johnson. It overlooked the town and was the center for the city's social, economic, and political activities until 1908, when East Rome became part of the town of Rome. Mr. Johnson was a newspaper publisher, textile mill operator, and plantation owner. The house had 18 rooms. Sliding pocked doors opened the parlor and dining rooms into a 2,050-square-foot great room.

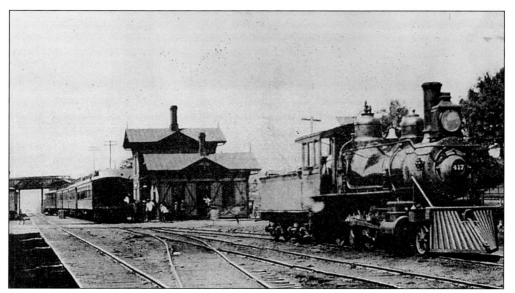

The East Rome Railroad depot was constructed in 1883 by the Virginia & Georgia Railroad Company. A wooden bridge was built over the Etowah River to allow the people of Rome to use this facility. In 1890, the original depot was destroyed by fire. A new depot was built and served the area until 1974, when it was also destroyed by fire.

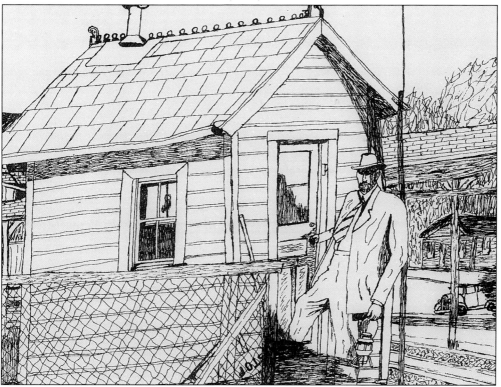

The railroad company constructed a gatehouse, where a keeper watched the train, wagon, and later, automobile traffic. He lowered the gate to stop traffic when a train was approaching the road. Today this is done automatically.

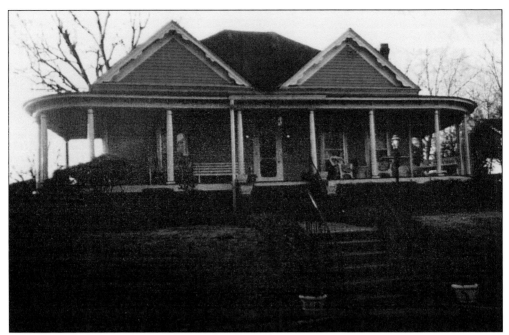

The Beysiegel Home was built by a Mr. Hamilton, a local carpenter. George Beysiegel, son of George and Ollie, was a cashier at the National City Bank. He also designed the bank's letterhead. John Tilly purchased the house in 1925. The interior is today basically as originally constructed, with massive mantles gracing four fireplaces. The Tilly family still occupies the house today.

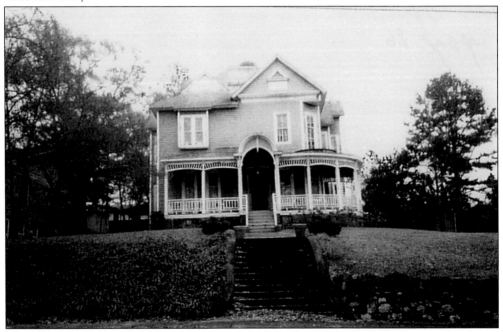

Eligaah M. Meda contracted the construction of the Meda-Moultrie House c. 1891. It is a Queen Anne-style structure. The Waters family are the current owners and are restoring the house as near as possible to its original condition.

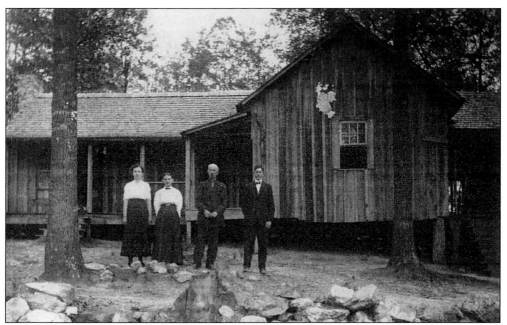

The town of Wax was established prior to the Civil War. The courthouse was situated to the right of the Lloyd home (pictured above) and contained a post office. It was later connected to and became part of the house. Pictured from left to right are: Nora Lloyd Stepp, Lizzie Lloyd, Berton Lloyd, and Walter Lloyd.

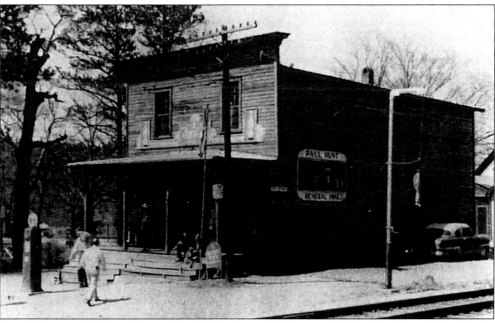

Porter's Store *c.* 1890 was located beside the Central of Georgia Railroad tracks in Silver Creek. The Silver Creek Post Office was originally within this building along with a general store. J.B. Porter built this structure. James Porter ran the store, and Lorilla Sharp was the postmaster. Note the pole for hanging the mail bag which was picked up by the passing trains.

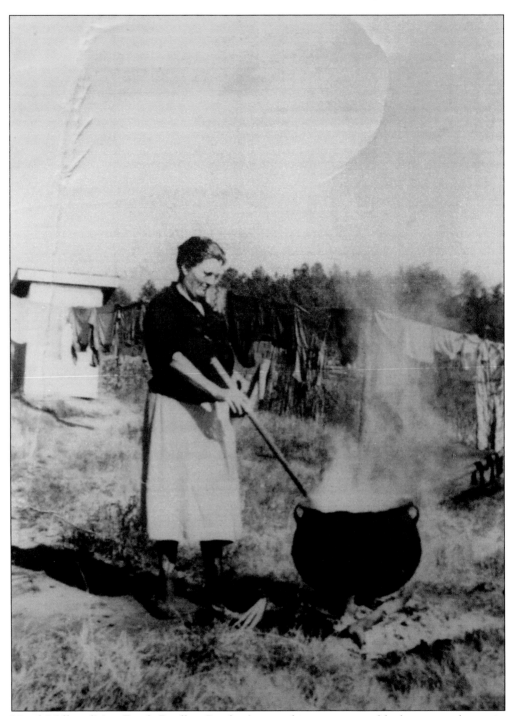

Hazel Miller, (Mrs. Frank Bradley Sanders), is making soap in a black iron wash pot in 1938. She was on the Porter Farm at Pinson Station. Most families made their own soap during and prior to this era. This was before most rural areas had indoor plumbing. Notice the outhouse in the background. The clothes in the background were boiled, hand washed, and hung out to dry.

This is a recent photograph of the old cotton gin at Pinson Station. No wagons are lined up waiting to have their loads of cotton turned into neat bales. Mr. Lee Drummond built this gin in 1930. Herbert Nichols operated the gin until it was purchased in 1962 by Oren Dodd and Orman Jones, who then operated it together.

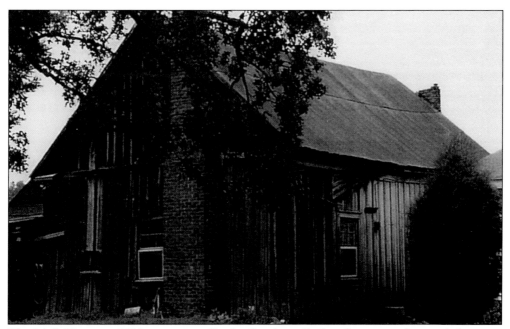

The Mull House c. 1900 was originally the Southern Railroad's section foreman's home at Seney. Mr. Raymond Mull purchased the house and moved it off the railroad right-of-way. No one from the Mull family lives there today. It is currently a rental house.

Bernice Couey Biship, local poet, newspaper columnist, and freelance writer stands in front of the old saloon in Seney, Georgia, in Floyd County. The town of Seney, like so many others, is today only known by historical researchers and the few remaining elderly residents who grew up there.

Seney was large enough to require the construction of a jailhouse. Perhaps the patrons of the saloon were sometimes rowdy.

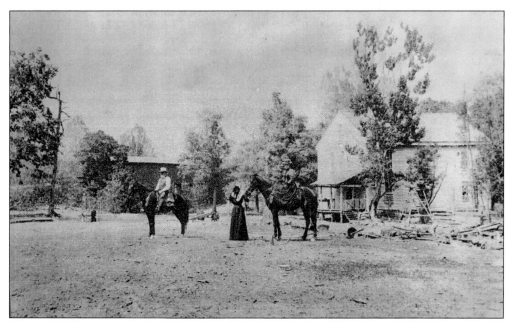

Thomas Mill was established on Big Cedar Creek in west Floyd County by a Mr. Thomas c. 1830. The town consisted of a gristmill, general store, post office, and scattered residences. Mr. Thomas is mounted on a horse in this photograph.

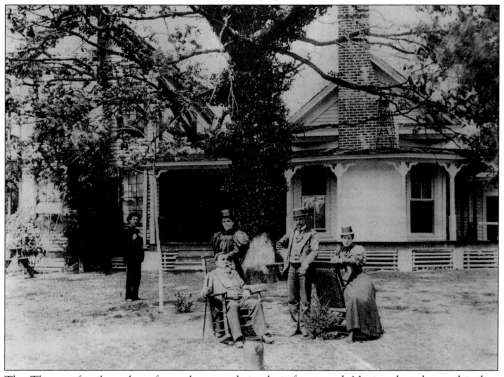

The Thomas family gathers for a photograph in their front yard. Notice that the yard is dirt. Few people had grass lawns during this era, as the only way to cut the grass was by hand sickle. Most of the yards were swept clean with a bush branch broom.

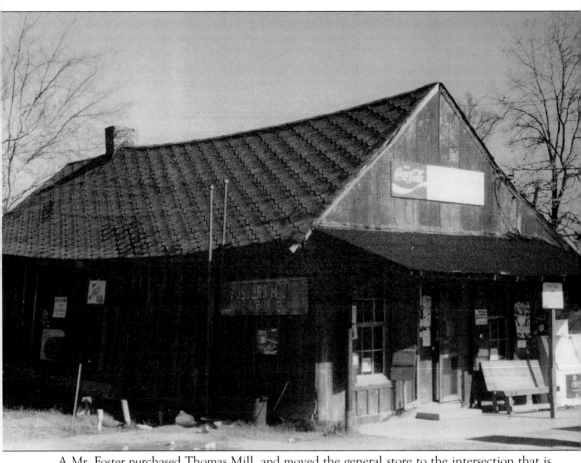

A Mr. Foster purchased Thomas Mill, and moved the general store to the intersection that is today the junction of H-100 and Black Bluff Road. The store is still in operation, and is all that is left of Thomas Mill. The area is now called Foster's Mill, although the mill is no longer there.

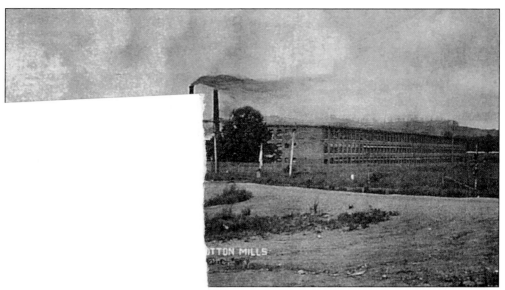

d land and constructed a mill near Silver Creek. The
eam until 1921, when it was converted to electricity.
per 2 was added, and later Mill Number 3 was added.
Manufacturing, which is one of the largest employers

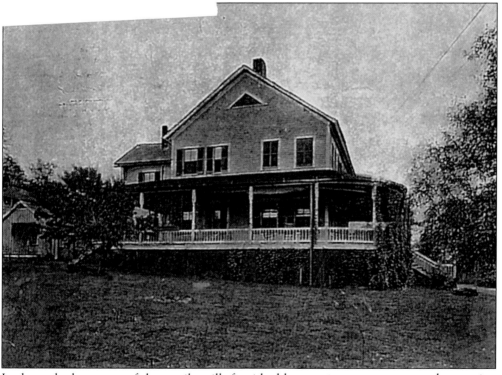

In the early days, most of the textile mills furnished houses, a company store, and recreation
areas for their workers. This photograph is of the Lindale Manufacturing Company agent's
home. He was the overseer of all matters involving company property.

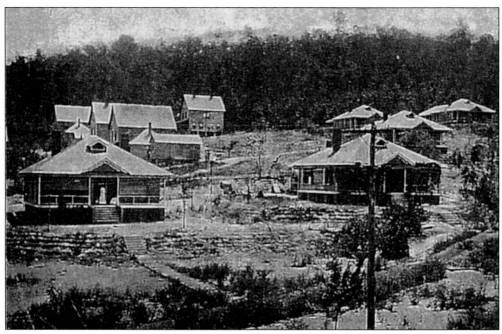

This photograph shows part of the village of Lindale. Residents of these homes worked for Lindale Manufacturing.

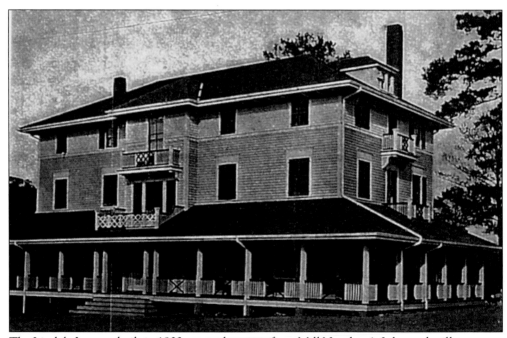

The Lindale Inn was built in 1903 across the street from Mill Number 1. It housed mill company officials and visitors. The inn had eight guest rooms and two baths on the second floor. It was closed down in 1951.

The McArver House in Coosa was built in 1870. As with most houses of the era, the kitchen was built away from the main house in case of fire. A general store was constructed beside the house. During the Civil War a Confederate soldier who was delivering a message was shot by a Union soldier. He is buried near the house.

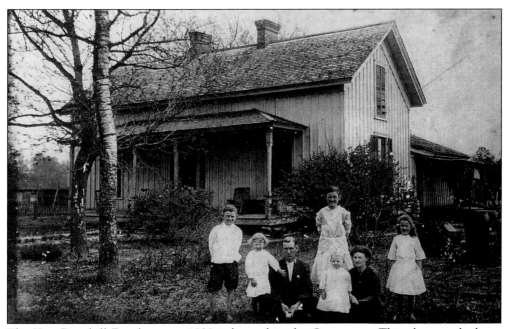

The Kerr Berryhill Farmhouse c. 1830 is located in the Coosa area. This photograph shows some of the family in front of the house in 1913. Pictured from left to right are: Lynn, Ann, Jack, Blanche, Alford, Mary, and Martha.

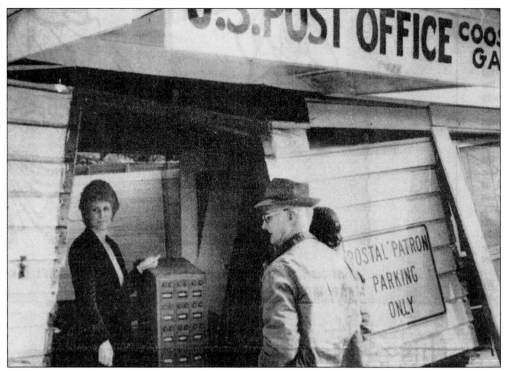

Dr. Hugh Quinn (a Moravian missionary) was appointed as the first Coosa postmaster in 1837. The post office was moved to the McArver store in the 1870s. In 1940, a new post office was built facing a new road. This building was struck by cars three times. The last accident, in 1982, prompted a new one to be built down the road. This picture shows Postmaster Lois Holbrook on the job after the final incident.

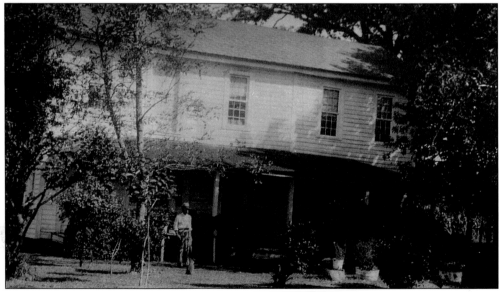

W.E. Vann built his home c. 1900 in the Coosa area. He then traded it for the Canfield home and land nearby. The Bridges family lived in this house until it was purchased and demolished by the Department of Transportation for a new road right-of-way.

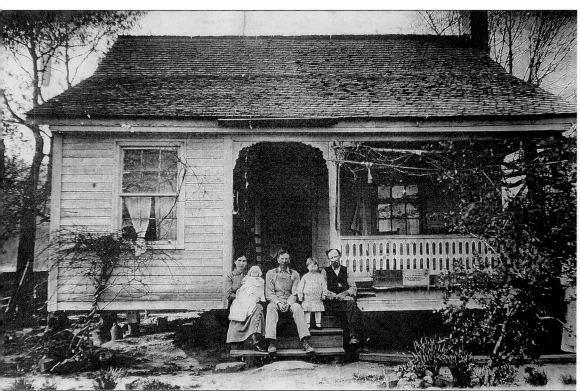

The Dr. Canfield home was built in 1852. He traded this property to W.E. Vann in the early 1900s. Dr. Canfield later moved to Arkansas. Pictured from left to right are: Mattie Vann Lloyd, Frances Lloyd, Arthur Lloyd, Lucille Lloyd, and W.E. Vann. This home is today occupied by Arthur W. Lloyd, son of Mattie and Arthur Lloyd.

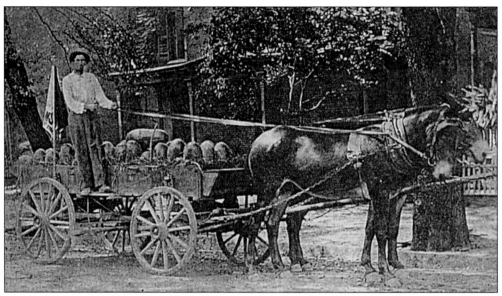

Mr. Deo Johnson was known for the large watermelons he grew on his farm. Each year he loaded his wagon with watermelons and peddled them from house to house in the Shannon, Adairsville, and Plainsville areas. Farmers often sold their fruits and vegetable crops this way. City dwellers were anxious to purchase the fresh-picked items from them, as they were brought to them without them having to leave home.

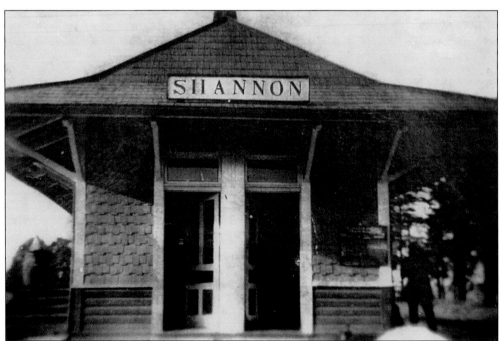

The Southern Railroad Depot at Shannon, Georgia, was built in the 1940s. When the railroad companies began to dispose of their depots, this one mysteriously disappeared over night. Local residents speculated that "someone had stole it," as one night a crew cut it in half and hauled it away to an unknown location. There is no confirmation of this story.

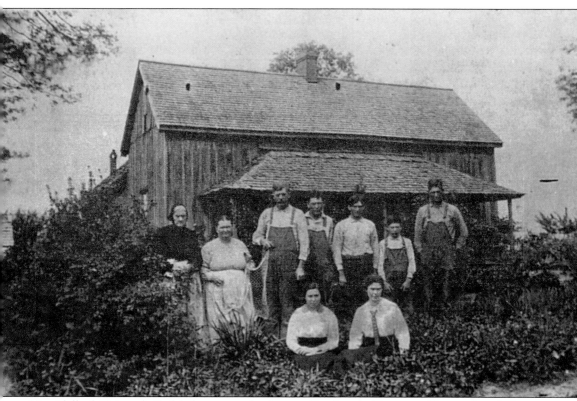

Mr. Clifford Gaines built his home on the Pinson Road near Shannon. He purchased the materials from Shaw Lumber Company at a total cost of $350 for the house and barn. At the time of this photograph it was owned and occupied by his son, William Gaines.

Many Floyd County residents did not have indoor plumbing until the 1950s. This picture shows the outhouse and a shed at the Gaines house.

Three

CAVE SPRING AND ROME

The first European descendant settlers to arrive in Vann's Valley came years before the Cherokee were driven out in 1838. They built houses and established farms and churches. Cave Spring was one of the first areas in Floyd County settled in this way, but was not incorporated as a town until 1880. This photograph shows part of Cave Spring as it looks today.

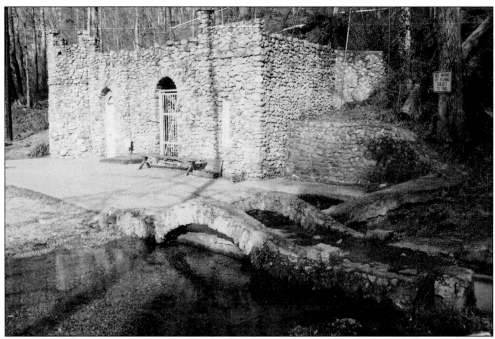

Cave Spring was first named Temperance Town. The name was soon changed to Cave Spring, recognizing the presence of a limestone cave from which flows a crystal clear mineral spring. The spring produces millions of gallons of water daily and today furnishes it to the city and surrounding area.

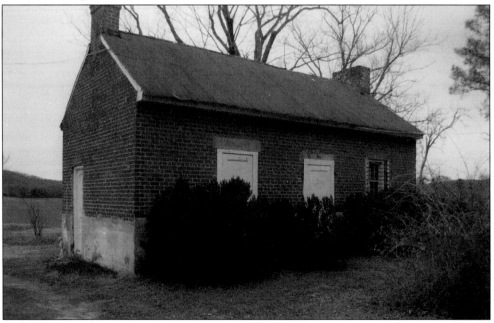

David Vann, a Cherokee, owned the land and had the original house (pictured above) built on this property. He stayed here when traveling in the area. A Mr. Lake won Vann's property in the Georgia Cherokee Land Lottery. He built a larger house in front of the first one and used Vann's house as his kitchen.

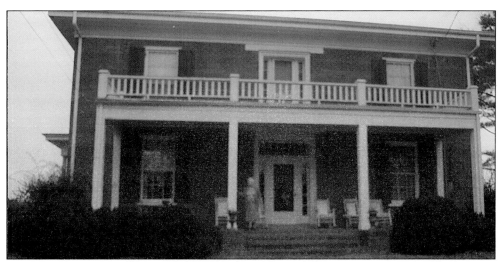

The Simmons, Lake, Cunningham, Montgomery, Wesley Home is one of the jewels of Cave Spring. This antebellum house is much as it has been for well over one hundred years. The furnishings, wall handpaintings, and gold trim are original. The brick walls are 14 inches thick. Mrs. John Wendell Wesley currently resides here. This gracious lady gave my wife and me a special tour of the house.

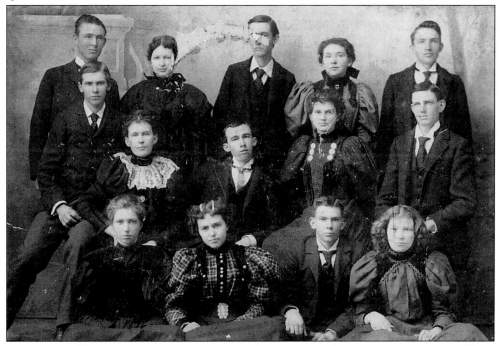

Part of the Montgomery family is pictured here. Shown from left to right are: (front row) Leila Montgomery, Rosalie Montgomery Sewert (mother of Mrs. J.W. Wesley), Lamar Montgomery, and Emma Montgomery Waters; (second row) Green Montgomery, Mae Montgomery Stringer (first marriage) Adams (second marriage), Albert Montgomery, Lillian Montgomery, and Clarence Montgomery; (third row) John Montgomery, Hattie Montgomery Stroit, Paul Montgomery, Mattie Montgomery Bass (first marriage) Abrems (second marriage), and Julis Montgomery.

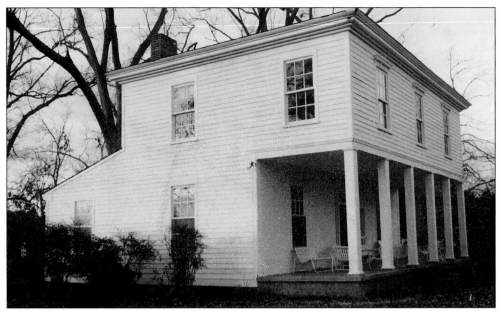

The William Penn Rivers House was built in the 1850s. Mr. Rivers willed his property to his three daughters. The three daughters died without heirs. In 1929, the J. Scott Davis family, relatives of the Rivers, moved into the house. The house and land were deeded to Martha Davis by Pearl Rivers (the last of the Rivers family). "Miss Martha," who was born in 1899, lives here today.

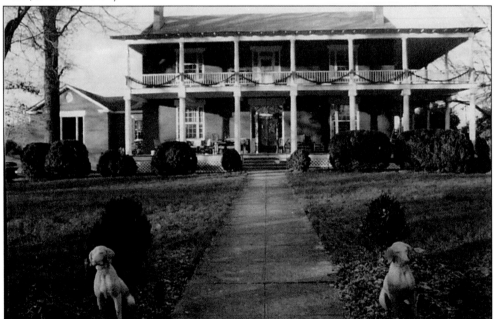

The Cowdry, Hight, Casey, Hunter, Kibler house was built in the 1840s. Its builder, the Reverend William D. Cowdry, erected this structure as a private school for girls. The house has been remodeled several times and the outside kitchen was torn down. The original wide plank flooring, door locks, bubbly handmade window glass, and folding doors still attest to its grandure.

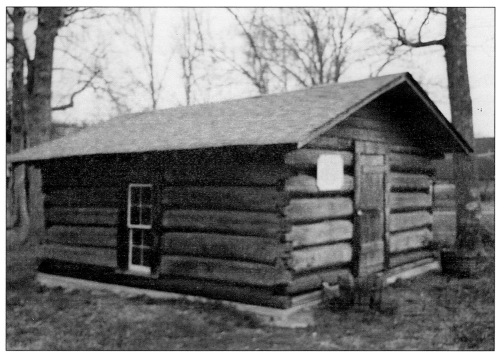

This log cabin is located in Rotary Park in Cave Spring. It is a reproduction of the one originally used as the First School for the Deaf. D.P. Fannin (the assistant principal of the Hearn School) was asked to undertake the education of four deaf children. He began this endeavor in a log cabin located behind the Hearn School. The year was 1846.

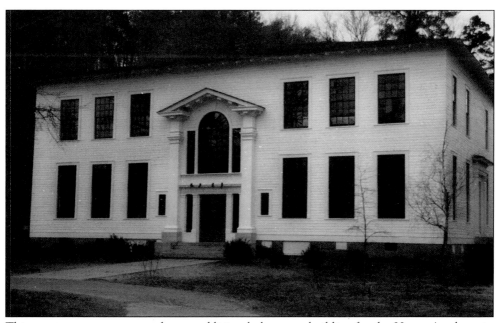

This structure was constructed as an additional classroom building for the Hearn Academy in 1910. It is located near the spring which comes from the cave in Cave Spring.

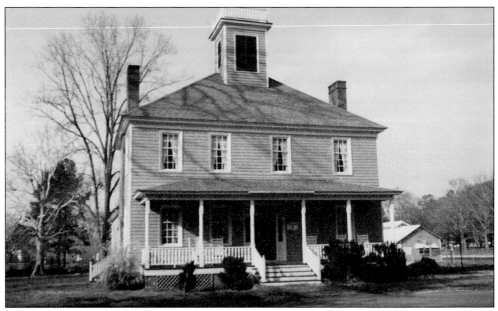

The Manual Labor School for Boys began operations in 1838. In 1844, Lott O. Hearn died and left an endowment fund for the school. The school's name was then changed to Hearn Institute. In 1888, a school for girls was chartered. The girls' and boys' school combined to form the Hearn Academy, in Cave Spring. This picture is one of the dormitories. Today it is a bed and breakfast inn.

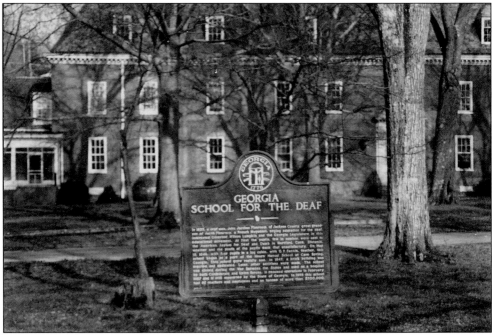

Two years after its humble beginnings, the School for the Deaf constructed its first building and named it Fannin Hall, after D.P. Fannin. This photograph shows it as it looks today, much modified from the original structure. The original, beautiful, ornate, external design is no longer there.

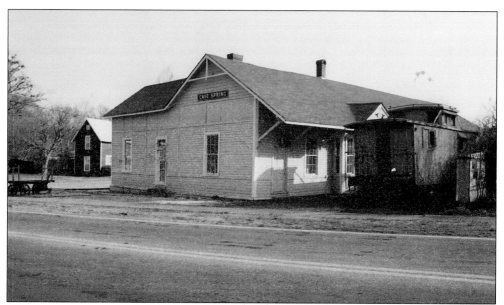

Southern Railroad Company extended their tracks to, and built a depot in, Cave Spring in 1869. With the rails came new commercial activity. Many visitors came to the spring believing it had medicinal qualities. Cave Spring became a popular vacation destination. Three hotels were built to accommodate the guests. The railroad stopped coming in the 1950s and the depot fell into disrepair.

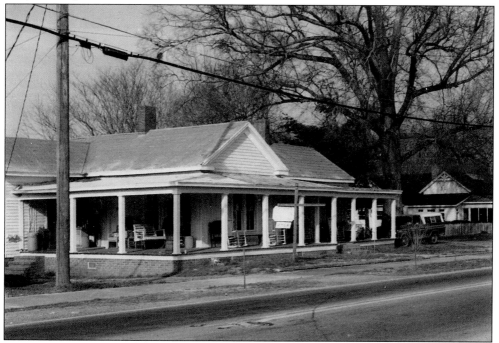

Today Cave Spring is much as it has been. The townspeople have strived to keep it that way. The down side to this is that without new industry few jobs are available, so most residents must seek employment in other towns. The stores and homes downtown have become antique shops, and Cave Spring a tourist destination. This photograph is of a home used as a shop.

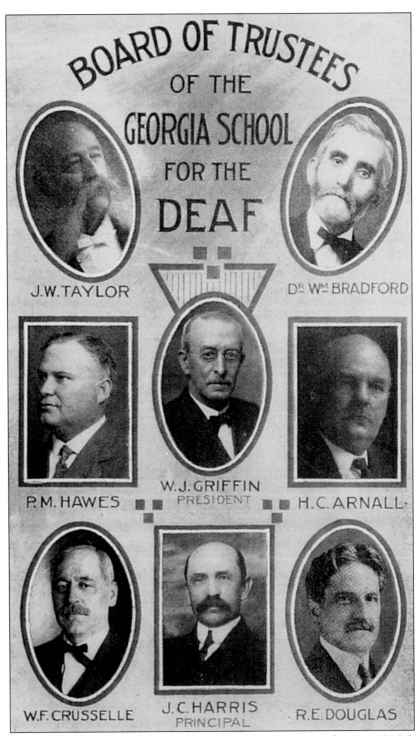

The Georgia School for the Deaf was developed from the Hearn Academy in 1846. It was the tenth such school established in the United States. Pictured is the 1916 Board of Trustees.

In 1876, the Georgia State Department of Education purchased the Cherokee Wesleyan Institute Building from the Methodist church. It was converted to a school for "colored" deaf children. F.M. Gordon was its first principal. His wife, Lucinda Gordon, was matron. The Wesleyan Institute was, prior to this, used for high school and college classes. This building was located on the hill top and overlooked Cave Spring.

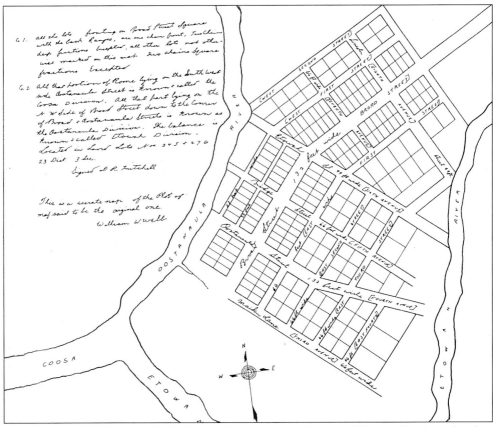

Daniel R. Mitchell designed the layout for the original town of Rome. He drew the first map of Rome in 1834. The town lay between the Oostanaula and Etowah Rivers. Three hills were within its original limits: Blossom Hill and those known today as Clock Tower Hill and Old Shorter Hill. There was no public square. The courthouse was located on a lot on Howard Street.

This view of Rome is from the top of Myrtle Hill c. 1880. The riverboat docks, railroad yards, water tank, city clock, Neeley School, and Shorter College are all shown in this photograph.

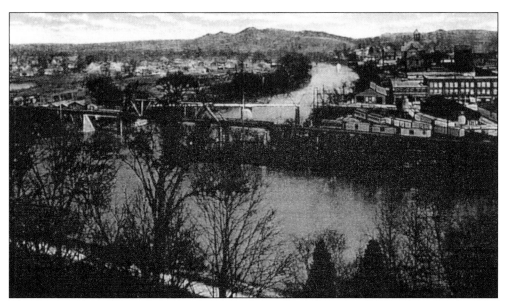

The Oostanaula and Etowah Rivers come together to form the Coosa River. These are the three rivers of Rome. The town of Desoto is to the left in the photograph.

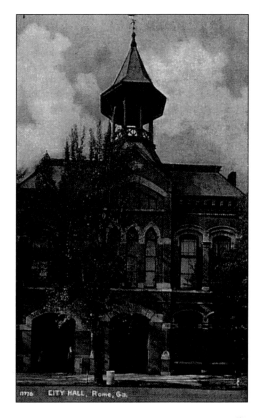

This is a photograph of Rome's original city hall. It was located on Oostanaula Street (today 4th Avenue) near the Oostanaula River. A wind storm blew the tower off in the late 1800s.

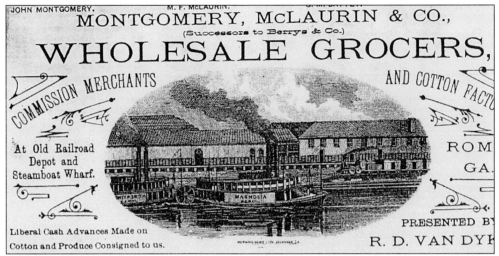

This view of the Etowah River shows Gibson's Wholesale Grocery on the north side of the river.

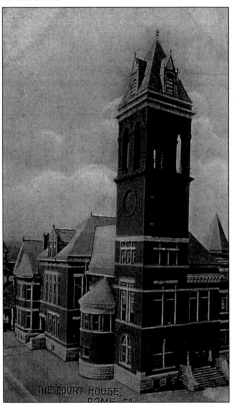

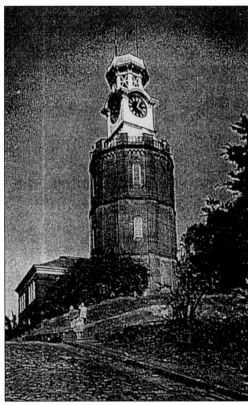

Left: The brick county courthouse on 5th Avenue was constructed in 1892–1893 and still has several county offices in it today. A new building has been built behind it which now houses most of the county government. *Right:* Rome's first water reservoir was built in 1871. This allowed water to be piped throughout Rome for firefighting and home use. The reservoir was serviced from two wells located near the railroad to the east. Water was not pumped from the rivers for this purpose.

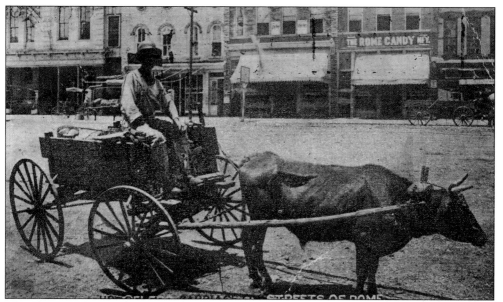

This photograph shows the way in which much of the manufactured and agricultural products were transported to markets prior to the availability of engine-driven vehicles. This photograph was taken in downtown Rome.

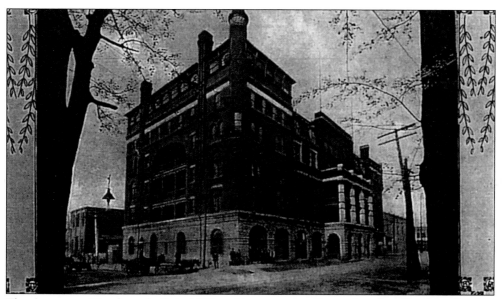

The Armstrong Hotel was built in 1888 and its name was changed to the Cherokee Hotel in 1900. The original structure caught fire in 1921. The fire, along with water from extinguishing the fire, caused major damage. The building, except for the lower level, was torn down and the Greystone Hotel constructed here.

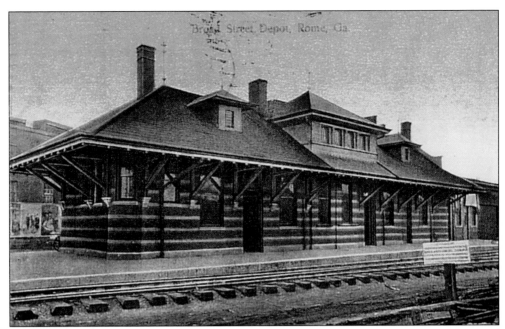

The Central of Georgia Railroad Depot was located on the corner of Broad Street and 1st Avenue. This beautiful building fell victim to so called progress, along with many other historically significant structures. In recent times, organizations have formed to prevent further destruction of historic buildings.

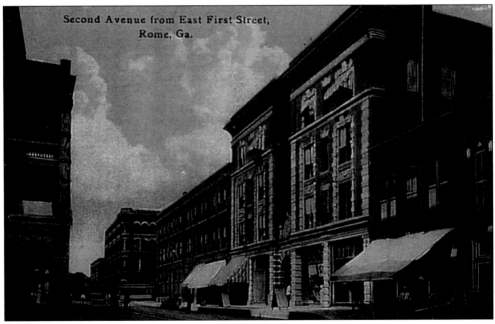

This view of 2nd Avenue, with the streetcar to the left and horse and wagon, shows Rome around the turn of the 20th century.

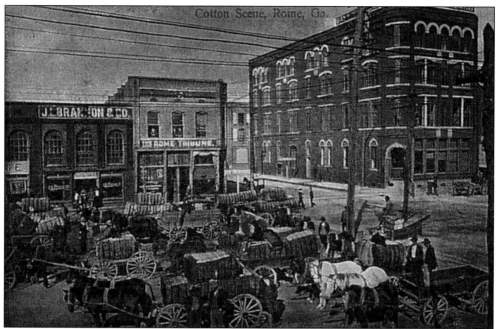

Cotton Factors (purchase agents) established offices on Broad Street near the Etowah River. This block became known as the Cotton Block. Farmers, after having their cotton ginned into bales, brought the bales here to sell. The cotton was stored in warehouses until it could be shipped from Rome by railroad or riverboat. This photograph was taken about 1880.

This cotton warehouse is located on 1st Avenue and is still used today by other businesses. During the Civil War, General Nathan B. Forrest housed prisoners here overnight. He paroled them the next morning and told them to go home. They were captured in Alabama when General Forrest tricked their commander. Forrest's forces were outnumbered four to one.

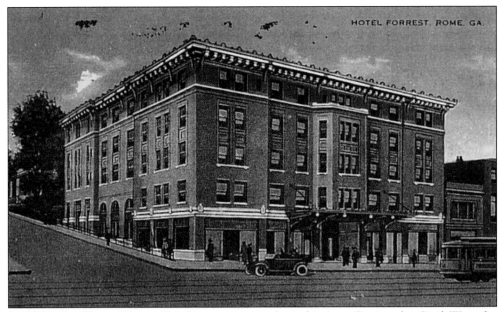

In 1850, the Choice House Hotel was constructed on this spot. During the Civil War, the mayor of Rome presented Gen. Forrest with a horse in front of this structure. In 1890, the name of the hotel was changed to Central Hotel. The building was destroyed in a fire, and in 1916 the Forrest Hotel was built on this site.

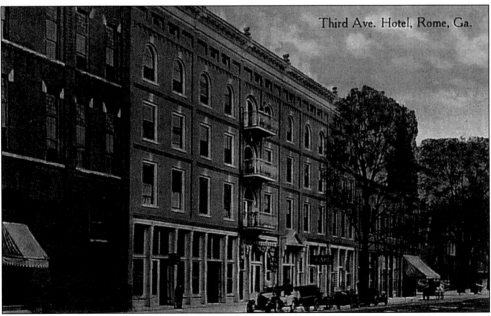

The 3rd Avenue Hotel was another of the fine accommodations travelers could utilize in downtown Rome in the early part of the 20th century.

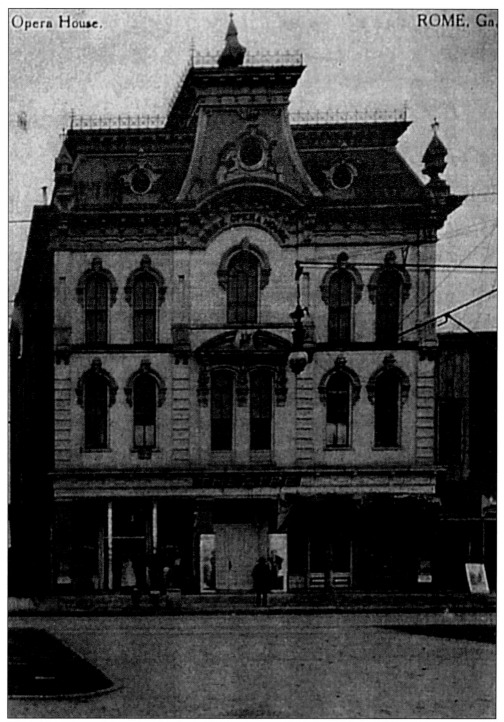

The Nevin Opera House was built and began operating in 1880. The building was constructed by Mitchell A. Nevin and Thomas H. Jonas. It had a seating capacity of one thousand, and its acoustics were highly acclaimed. Productions were abandoned in 1917, and the structure burned in 1919.

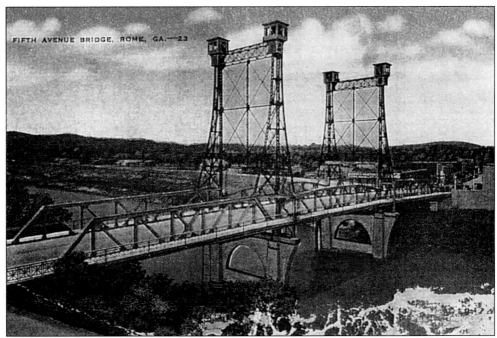

FIFTH AVENUE BRIDGE, ROME, GA.—23

In 1888 the county government paid $13, 457 for the construction of a bridge connecting Rome and Desoto across the Oostanaula River at 5th Avenue. The structure was built as a drawbridge. Heavy counterweights were used to raise the center of the bridge to allow riverboat traffic to pass underneath. The bridge towers were removed for scrap iron during World War II.

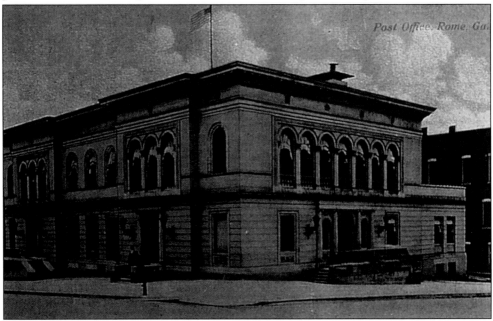

Post Office, Rome, Ga.

In 1896, the federal government built a large yellow brick post office at the corner of First Street and 4th Avenue. Through the years this structure has had three additions. In 1941, courtrooms were added. When a new post office was constructed, the county government took ownership of the yellow brick building.

The Masonic Temple, located on the corner of Broad Street and 4th Avenue, was constructed by J.A. Cooley in 1877. It has been the home of Cherokee Lodge No. 66 F&AM ever since. The building was burned by Sherman's troops during the Civil War. Some of the Northern troops were Masons, and after the war they sent funds to rebuild the temple.

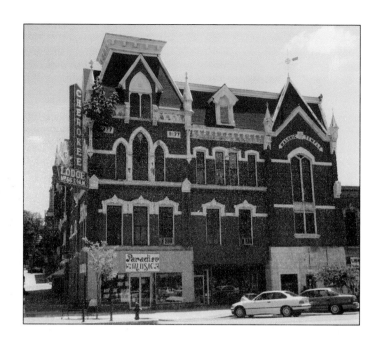

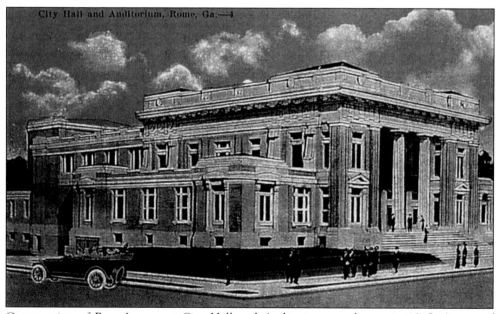

Construction of Rome's current City Hall and Auditorium was begun in 1915. A sum of $100,000 was originally budgeted for the project. It was later necessary to spend another $40,000 to complete the building. A.F. Brown was the architect and J.F. Dupree and Sons Co. was the general contractor. J.D. Hanks was the mayor when the project began. A commission form of government began in Rome on April 6, 1915.

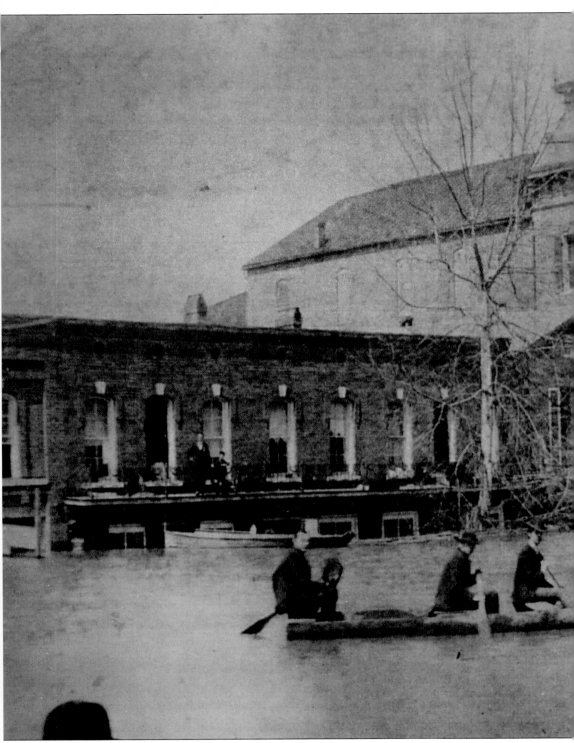

Prior to the dams being built upriver on the Oostanaula and Etowah, Rome experienced major floods. This picture is of Broad Street during the 1886 flood. The riverboat *Marilda* came off the

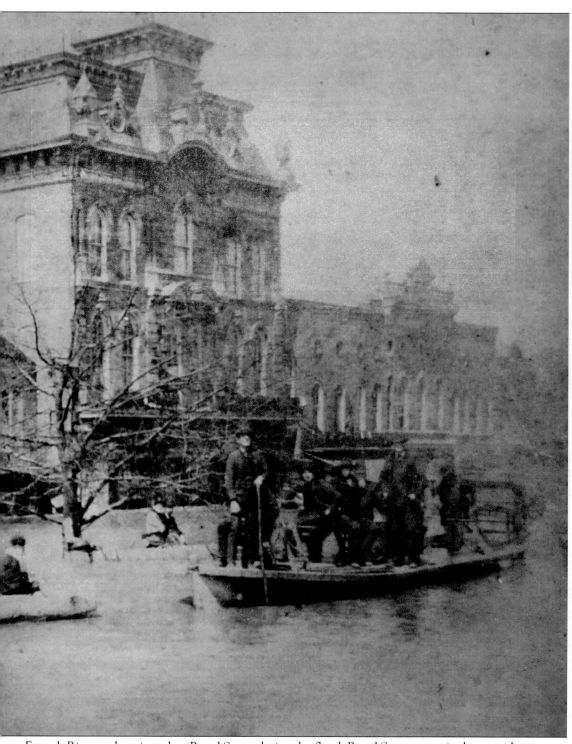

Etowah River and navigated up Broad Street during the flood. Broad Street was raised a second time after this flood necessitated the raising of the floor levels to match the new street level.

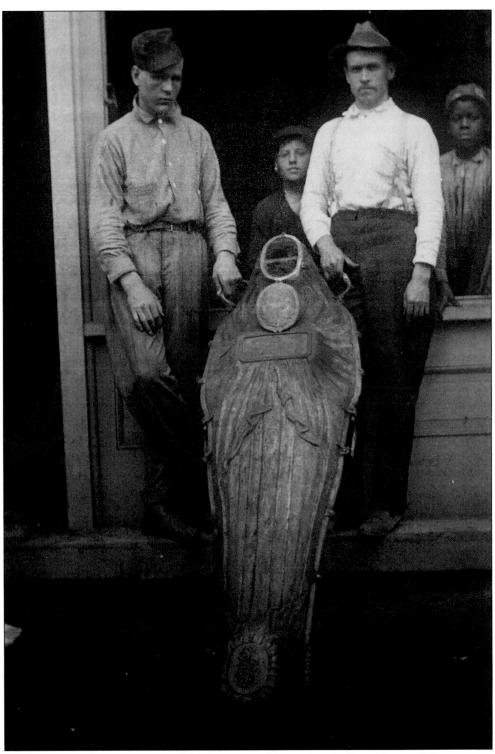

In 1913, iron coffins were removed from a graveyard located under Broad Street. Other remains were also removed. This one was reburied in the C. Attaway lot in Myrtle Hill Cemetery.

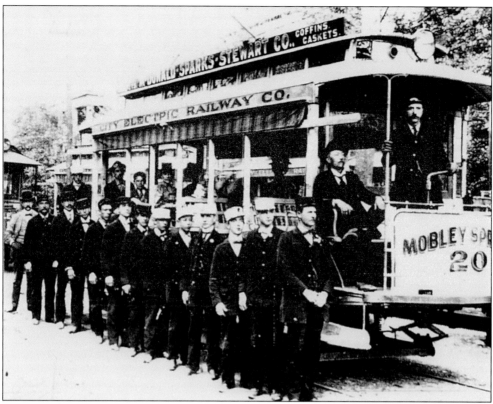

In 1884, the Rome Street Railroad Company was issued a permit to construct tracks and operate public transportation vehicles in Rome. Joseph F. McGhee, B.I. Hughes, T.F. Howell, and Daniel Lowry were the incorporators. This picture shows 14 drivers outside one of the streetcars, with passengers inside.

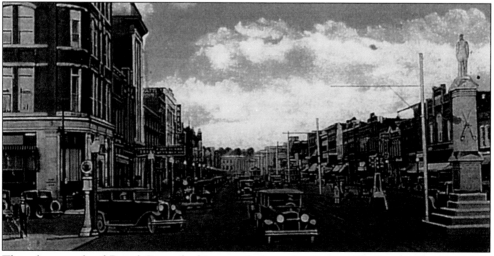

This photograph of Broad Street looking north from the Cotton Block was taken in 1920. Notice the gas pump on the corner and traffic lights on pedestals in the middle of the street. The street is so wide that traffic traveled in both directions on either side of the street's center at that time.

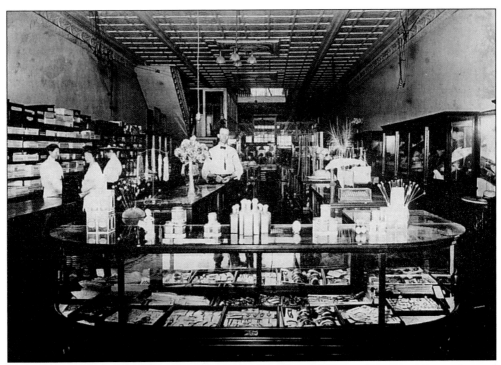

In 1917, this photograph was taken inside Harkins King Millinery Company. It was located at 228 Broad Street. Company officers at this time were Issac May, president; Lou King, vice-president; and Lucile Hawkins, secretary/treasurer.

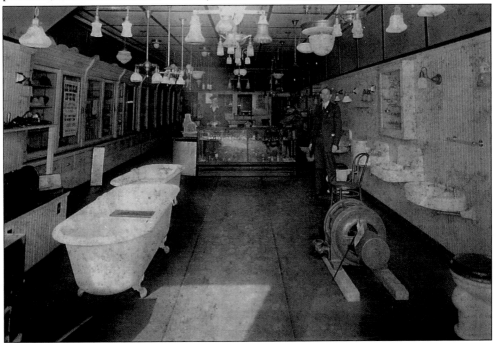

In 1917, Walker Electrical was located at 329 Broad Street. They were plumbing, heating, and electrical contractors.

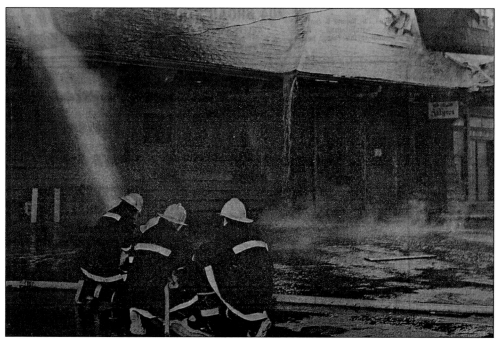

The depot in east Rome burned twice. This picture shows firemen making a gallant effort to save the depot the second time it burned.

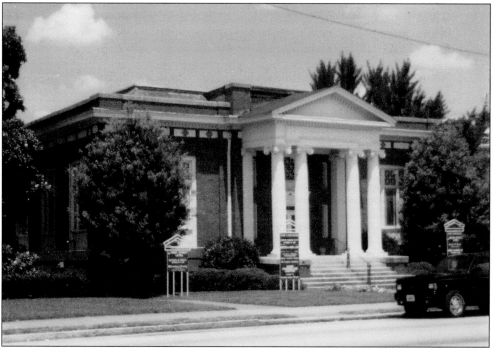

Carnegie Library was a gift from philanthropist Andrew Carnegie. It opened on May 2, 1911. Helen Eastman was the first librarian. She served for 33 years. This building is currently leased out as office space. Rome's new library is one of the finest anywhere. It sits on a hill overlooking the Oostanaula River.

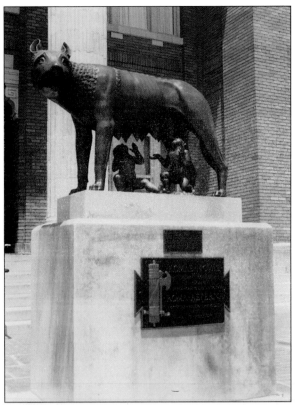

Standing in front of Rome's City Hall is a statue reproduction of a mother wolf nursing two human infants. The plaque mounted on its base reads in Italian as follows: THIS STATUE OF THE CAPITOLINE WOLF AS A FORECAST OF PROSPERITY AND GLORY HAS BEEN SENT FROM ANCIENT ROME TO NEW ROME, DURING THE CONSULSHIP OF BENITO MUSSOLINI IN THE YEAR 1929.

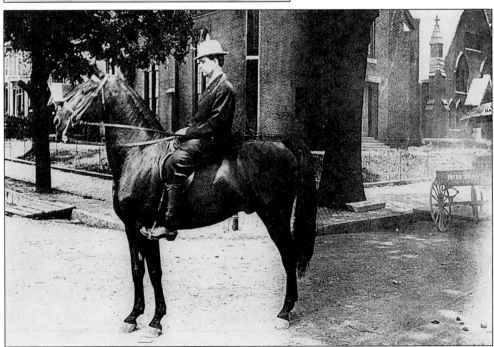

Dr. T.E. Lindsey was one of the first veterinarians in Floyd County. He is shown here on his horse, Chester. Dr. Lindsey practiced veterinary medicine from 1902 until 1949.

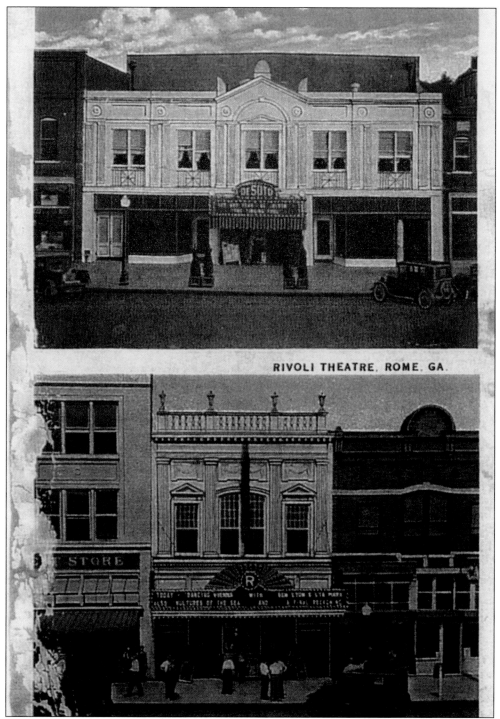

RIVOLI THEATRE, ROME, GA.

Downtown Rome had several theaters in the late 1920s and early 1930s, two of which are pictured here. Early writings describe the Desoto as the "finest in the South," and "a talkie house constructed to be used for sound pictures." The first film shown at the Desoto was *Eddie Dowling, Broadway Singing Comedian*. The Rivoli Theater has a similar history.

Paul Nixon was the founder of the Lindale Band and the co-founder of the Rome Symphony Orchestra. He was also the first conductor of this orchestra. He served in this position from 1921 until WW II.

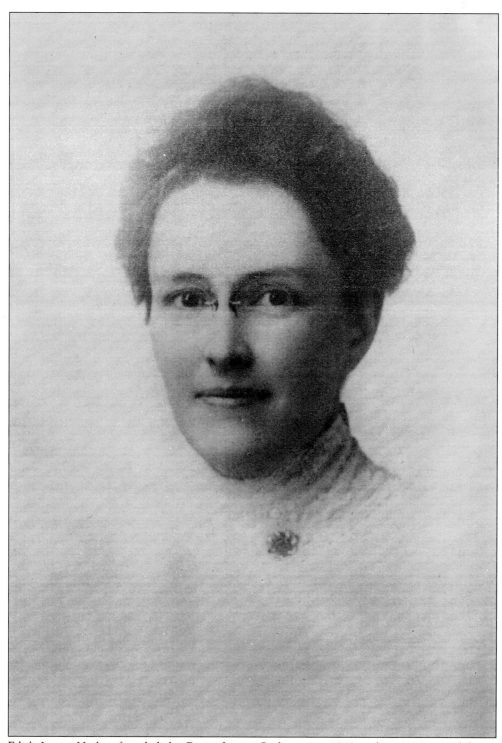

Edith Lester Harbin founded the Rome Junior Orchestra in 1919 and in 1921 joined forces with Paul Nixon to form the Rome Symphony. This event was the result of combining the Lindale Band and the Rome Junior Orchestra.

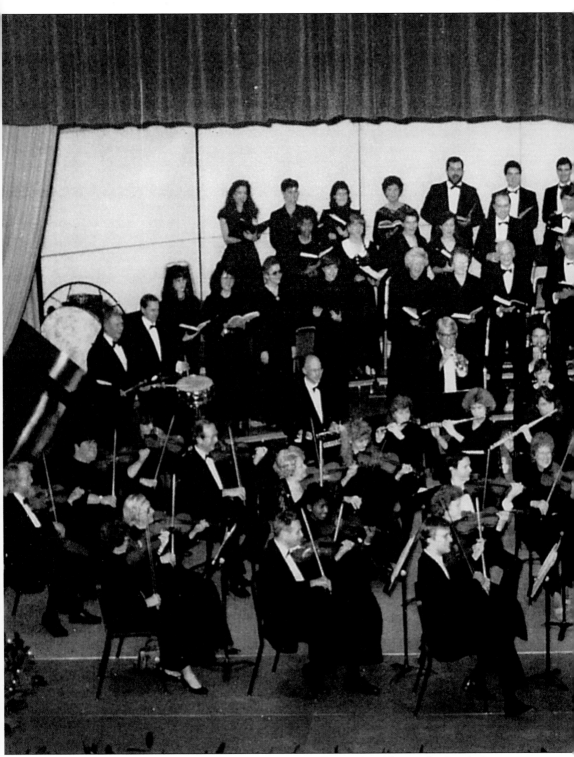

Rome's Symphony Orchestra has the distinction of being the oldest in the South. It is enjoying its 78th year. The photograph shows the orchestra in concert with John Carruth conducting.

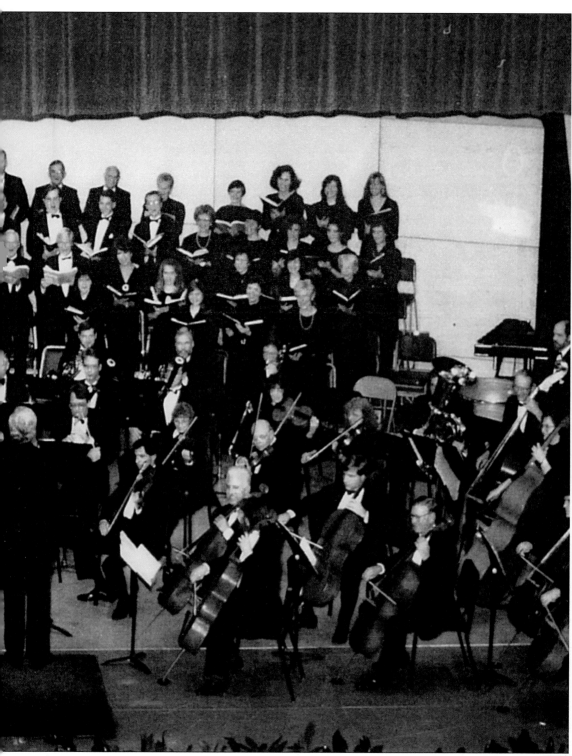

Paul Nixon, Helen Dean, and John Carruth have all served as conductor.

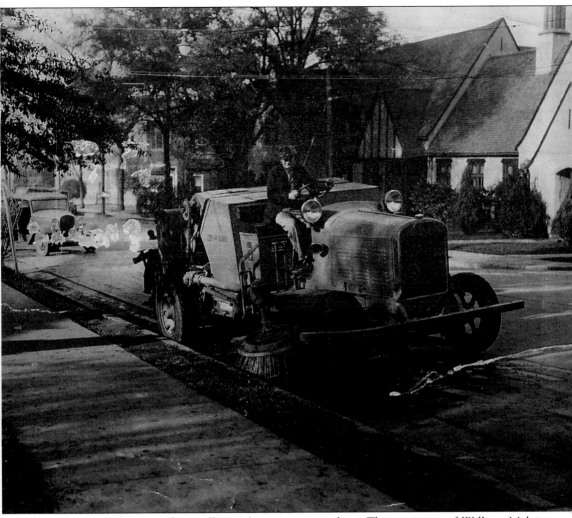

Rome has always made an effort to keep its streets clean. This picture is of William Melvin House operating a street sweeper in front of the Emmitt Cole Funeral Home on 6th Avenue, in 1936. Mr. House was shop mechanic for the Rome city garage.

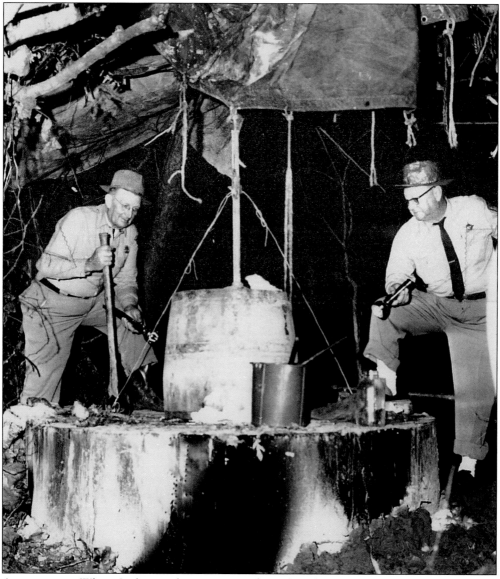

At one time, White Lightning liquor was made and sold in large quantities in Floyd and surrounding counties. This photograph shows Sheriff Joe Adams and Deputy Erwin Coker inspecting and about to destroy a whiskey still.

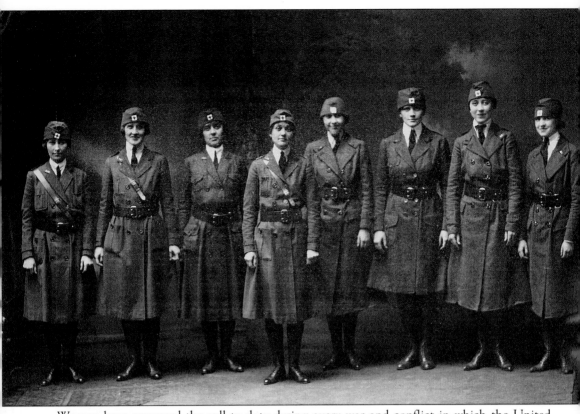

Women have answered the call to duty during every war and conflict in which the United States has participated. This photograph is of some from this area who served with the Red Cross during WW I.

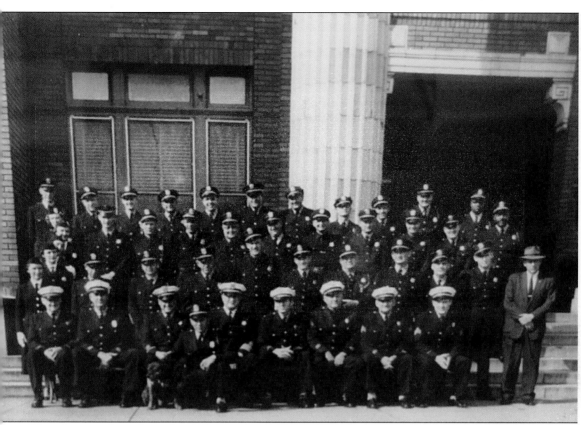

This photograph is of members of the Rome police force. Hundreds of pictures are available of various members, so it was difficult to decide which one to use. In this case I just chose the first one I saw. The Rome Area History Museum has a display dedicated to the police as well as all other subjects touched upon in this book.

This is a view of Rome from the top of the Clock Tower looking west. The old red brick county courthouse and 5th Avenue bridge are clearly visible, as are many other downtown landmarks.

Four

FARMING, INDUSTRY, AND TRADE

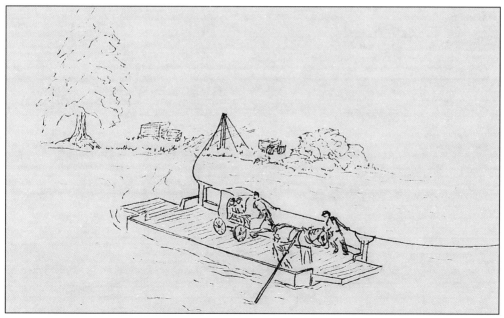

The first improved roads were built within the Cherokee Nation in the late 1820s. No bridges were built to carry traffic across the rivers. John Ross, Major Ridge, John Ridge, and James Vann, all Cherokee, built ferries to connect with the roads. The drawing represents Major Ridge's Ferry over the Oostanaula River. He charged 50¢ for a four-horse wagon and team to take the ferry.

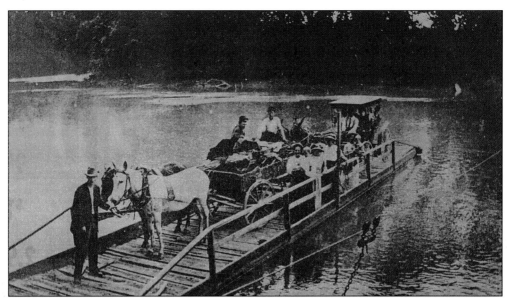

Miller's Ferry crossed the Oostanaula River near Reeve's Station. This photograph was taken in 1913. The people on the ferry, from left to right, are as follows: Lawrence Jones, Arthur Ward, C.E. Squires, Squires's mother and father, Mrs. Jones, Mrs. Ward, and Mrs. Squires. The three types of ferries were rowed, poled, and cable drawn. They were all manually operated.

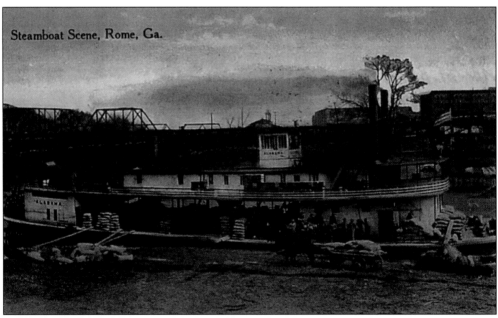

Steamboat Scene, Rome, Ga.

Riverboats began transporting cargo down the Coosa River to Mobile in 1845 and continued to do so until 1912. Their main cargo at first was lumber, wheat, corn, and later cotton. This photograph shows the Riverboat *Alabama* at dock on the Etowah River. This riverboat was a small one, as riverboats go. It was approximately 90 feet long.

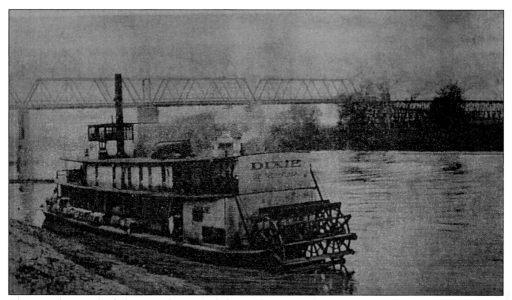

The riverboats plied their trade up and down the rivers from as far up the Oostanaula River as the Calhoun area, and as far southwest as Mobile. This photograph shows the Riverboat *Dixie* at the dock on the Coosa River in Gadsden, Alabama. When riverboats neared ferry cables crossing the river, the pilot would sound his whistle and the ferries would lower their cables deep under water.

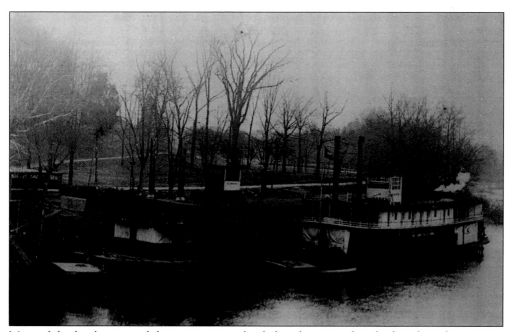

Most of the lumber moved downstream was loaded on barges and pushed to their destination. Note the barge attached to the front of one of the boats docked on the south side of the Etowah River in south Rome.

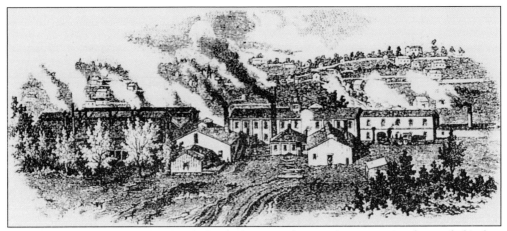

The Noble Brothers Foundry, located on what is today 1st Avenue, manufactured the first railroad steam-driven locomotive. They also produced some cannon for the Confederate Army during the Civil War. The foundry was later moved to Anniston, Alabama.

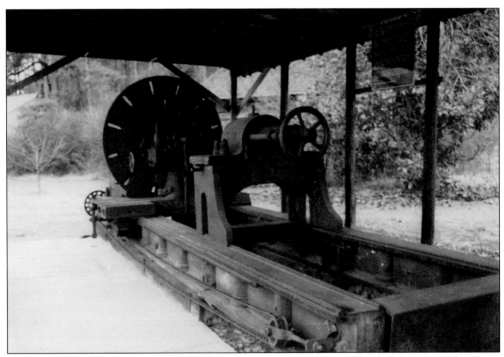

In 1855, the Noble Brothers Foundry began operating in Rome. The lathe pictured here was made in Pennsylvania in 1847. It was transported to Mobile by ship and then by riverboat to Rome. Railroad locomotives, steamboat engines, furnaces, and cannon were made using this lathe. It later served Davis Foundry and the Brewer and Taylor Foundry until 1972.

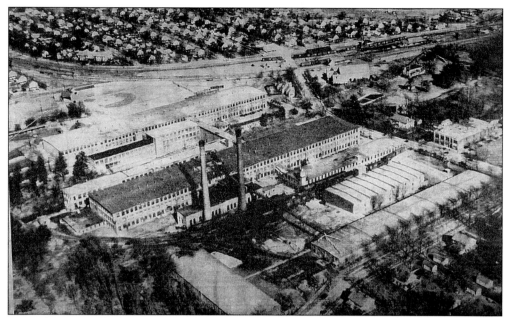

Massachusetts Mills constructed and began production in Mill Number One at Lindale in 1896. It was equipped with one thousand looms. Mill Number Two was built in 1898. Mill Number Three was completed in 1902. This completed the factory structures. The average earnings of their employees in 1898 was 5.3¢ an hour. This mill operates today as Lindale Manufacturing, Inc., and is still a major employer.

The Rome and Northern Railroad began operations in 1909. It was one of the many short-line railroads that once spread throughout north Georgia which no longer exist. This line's scheduled route began on Broad Street in Rome. It traveled through west Rome, Gammon, Brayton, Armuchee, Thomas, Chrystal Springs, Storey's Mill, and Shackleton before arriving at Gore. The line was built to connect Rome with the ore deposits at and near Gore.

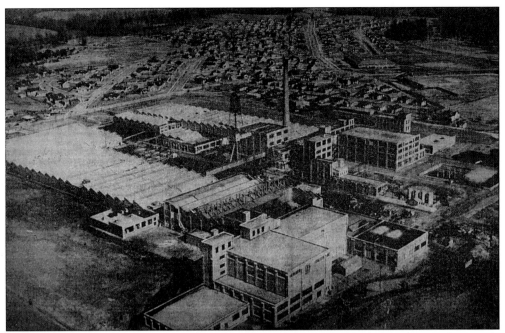

In 1928, the Italian-owned American Chatillion Company began construction of a textile mill just northeast of Rome. This mill opened under the name of Tubize and became a major employer in the area. The company constructed a mill village and other amenities for their workers. This plant is no longer in operation. Several other companies currently occupy the various buildings.

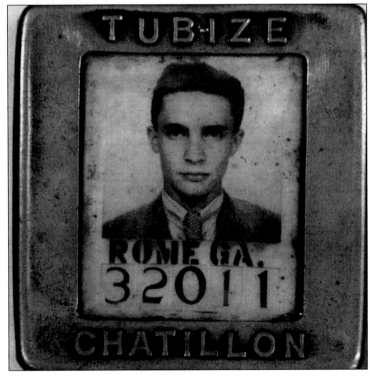

This picture shows a company badge of an unidentified Tubize worker. Employees were required to wear their identification badge while on company lands.

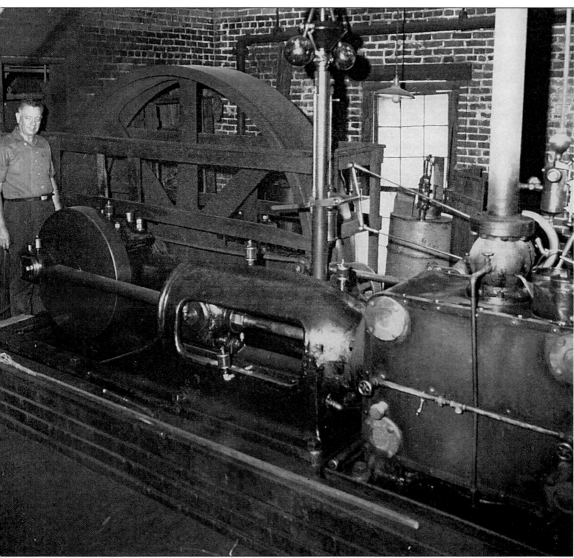

This Corless steam engine served Rome's Southern Cooperative Foundry from 1902 until 1971. This foundry produced stoves, heaters, ranges, and grates, helping make Rome the "Stove Center of the South."

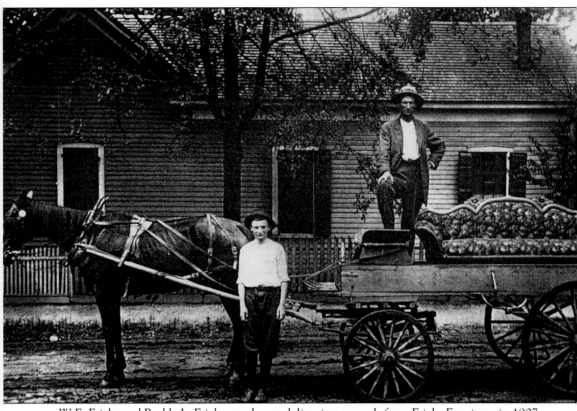

W.E. Fricks and Roddy L. Fricks are shown delivering a couch from Fricks Furniture in 1907.

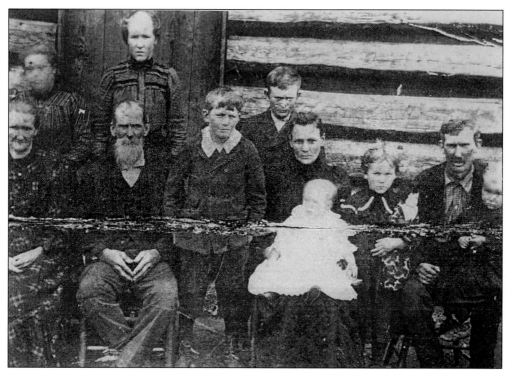

Not all farmers' homes were small log cabins. The Davis family, pictured above, are in front of their home in which 11 people lived.

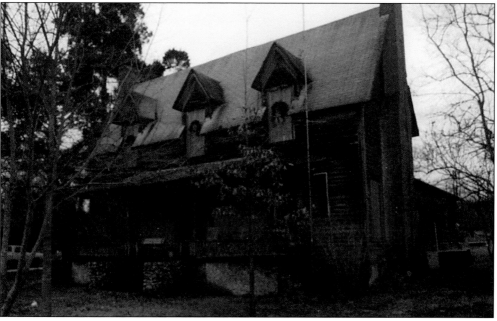

The Shaw House located on Jackson Chapel Road in southwest Floyd County was built in the 1860s. This is the second home at this location for the Shaw family. The original abode was a log cabin which still stands just south of the current one. Today it is used as a barn. The Shaw House is presently the home of Genelle Shaw Johnson and family.

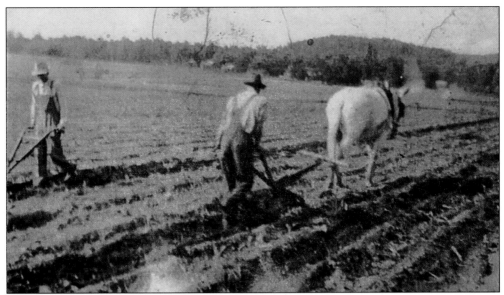

Before tractors made a farmer's life a little better, the fields were prepared for crop planting in the manner shown above. J.C. Lowery and Will Maddox walked many a mile behind a horse- or mule-drawn plow in scratching out a very hard-earned living for their families. Today a farmer with a tractor can do in one day what once took days to do.

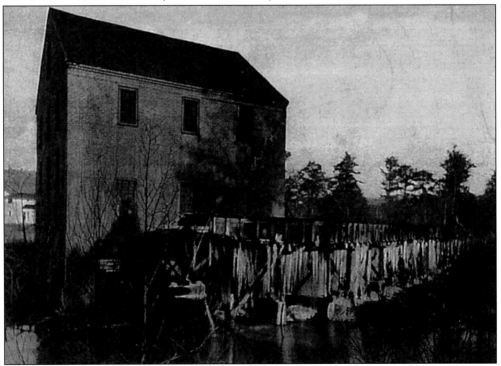

The gristmill in Lindale was the first one in Floyd County. Farmers took their corn or wheat here to be ground into cornmeal or flour. Their wives prepared cornbread or biscuits from these. Sometimes they made a special bread treat called hoe-cakes. This mill is much as it was when first built, only the water race is missing.

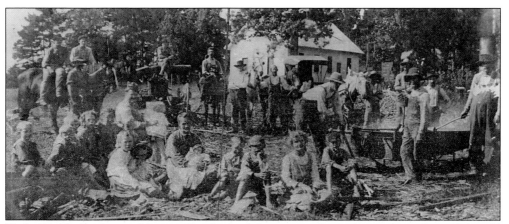

Elisha Smith Sanders and his son Frank are making syrup from sugar cane in front of the old Enon Baptist Church on a fall day in 1909. Sanders bought this syrup mill from the Salmon family. Frank Sanders later sold it to Jason Davis. Bee Couey and Joel Roy Sanders are sitting on horses. Seated on the ground are members of the Davis family.

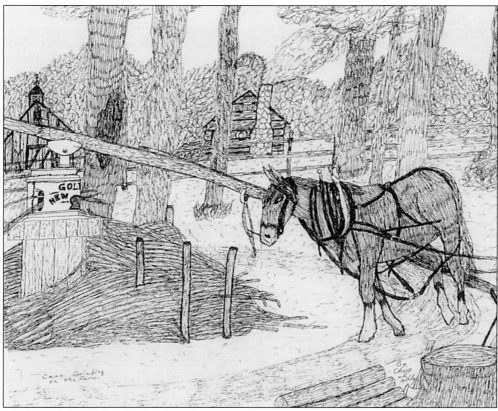

This drawing by Chip Tilly shows the tedious routine required of a mule (or other power) in grinding the cane and extracting the juice, which will be cooked down into syrup. Perhaps this is where the phrase "going 'round in circles" came from.

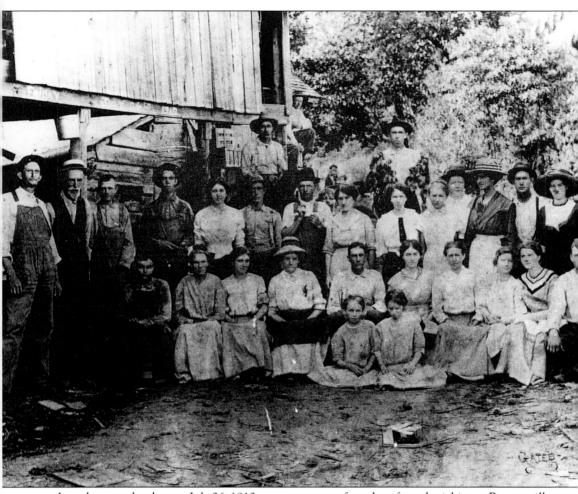

In a photograph taken on July 26, 1912, a crew prepares for a day of peach picking at Rounsaville Farm near Silver Creek. At one time peaches were a leading fruit crop in Floyd County. This photograph was taken in front of the packing house. Notice the empty crates stacked against the wall, ready to be packed with ripe peaches and shipped north.

This cotton gin today sits, as with many others, in desolation, no longer useful. At one time many gins were scattered throughout Floyd County. This one is near the old site of Livingston.

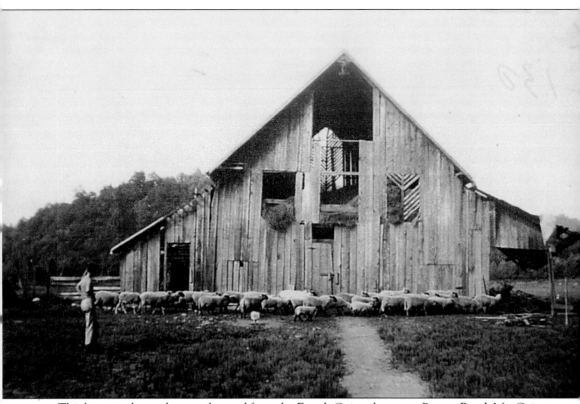

This barn was located across the road from the Enoch Gaines home on Pinson Road. Mr. Gaines was a well-known farmer who also owned a gristmill and store near his house. His grandson, G.A. Gaines Jr., is seen standing before a head of sheep in front of the barn. This scene was a rare one, as raising sheep was never a major enterprise in Floyd County.

Five

EARLY CHURCHES

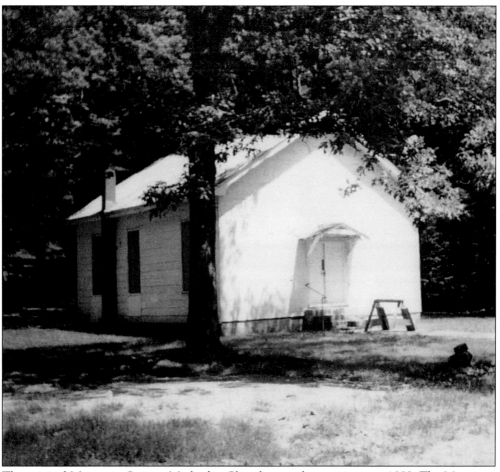

The original Mountain Springs Methodist Church was a log structure, c. 1880. The Mountain Springs area was once a thriving farming community in north Floyd County. The log church was replaced about 1900 using materials from the old Shiloh church. It was eventually deserted around 1950. Caring individuals renovated the building, and services began again in 1955. Services are held on the fifth Sunday of months having five Sundays.

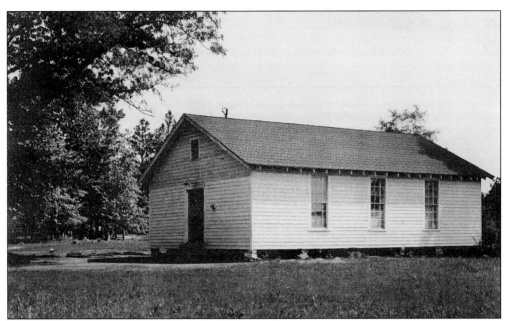

Mt. Pleasant Methodist Church was organized in the late 1860s. Reverend Sam Jones, famed evangelist, was pastor in 1876. It was destroyed by a wind storm in 1931 and then rebuilt as shown. The church was used as a school when a Coosa school was destroyed by fire.

Mountain Springs was apparently a popular name for churches in the 1800s, as more than one in Floyd County had this name. This photograph is one of the Mountain Springs Methodist Church on Agan Road in the southwest part of the county. It was established in 1881 and service is still held here weekly. The Reverend Neal Williams is the current pastor.

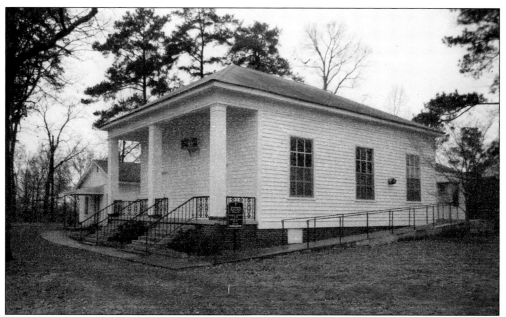

The Oostanaula Methodist Church near Shannon is still active after over one hundred years of service. Its current pastor is Rev. Alvin G. Busby.

The Oostanaula Methodist Church cemetery, like most old cemeteries in the South, is the final resting place for its share of men who fought for the Confederacy. This tombstone is a good example of such a resting place. Henry Shamblin's stone reads: 1840–1916 C.S.A. (Confederate States of America).

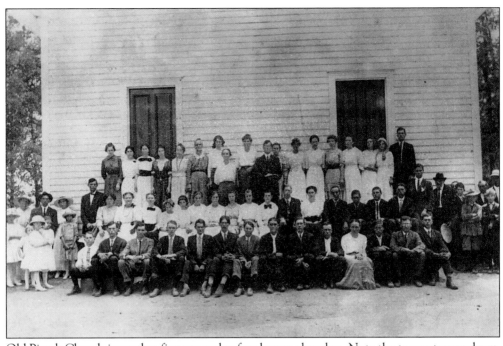

Old Pisgah Church is another fine example of early area churches. Note the two entrance doors. In the old days, men and women did not enter, leave, nor sit together in some churches.

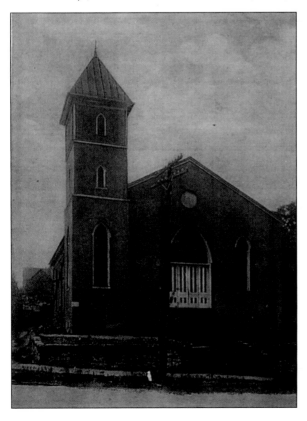

St. Paul's AME Church is located on 6th Avenue across from the post office in Rome. This is still today a black church. Why does man still separate himself from man? This greatly confuses this author.

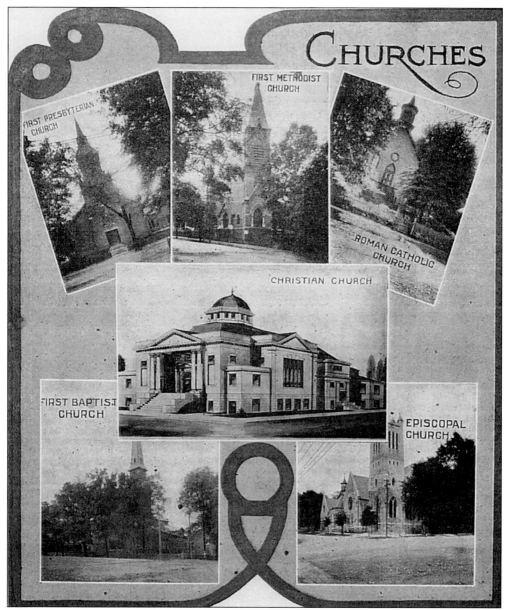

The early six downtown churches of Rome are shown on this copy of a 1940s postcard. The churches are the First Baptist, First Methodist, St. Peter's Episcopal, First Presbyterian, and First Christian.

The Sardis Church was constructed in 1837 near the Narrows, west of Coosa. When the road in front of the church was rerouted behind the structure, the interior was reversed so that the back was now the front of the church.

Six

GEORGIA'S FIRST
UNITED STATES
FIRST LADY

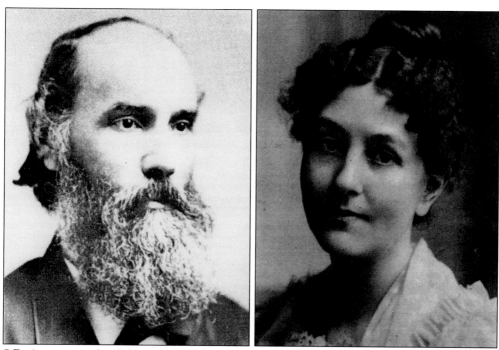

S.E. Axson was the father of Miss Ellen Axson (later Mrs. Woodrow Wilson). The Axson family lived in Savannah, Georgia, when Ellen was born. In 1865, after the Civil War, Samuel E. Axson moved his family to Rome where he became the pastor of the First Presbyterian Church in 1866.

After short residences in other locations, Reverend Axson built a parsonage at 402 East 3rd Avenue. The year was 1869. This is where the Axson children grew into adulthood. Ellen Louise Axson lived here when she met her future husband, Woodrow Wilson, who became the President of the United States.

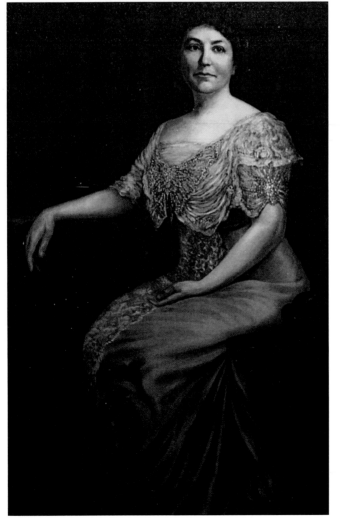

Mrs. Ellen Axson studied art at the Rome Girls' College. This is a photographic copy of her self-portrait. The original hangs in the Rome/Floyd County Public Library.

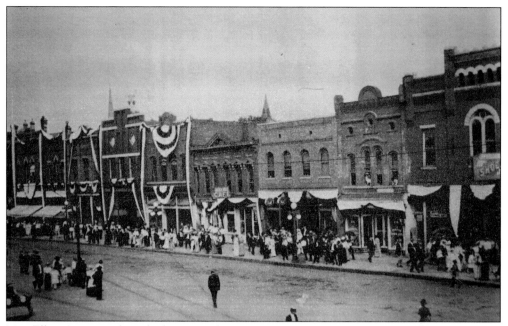

Mrs. Ellen Axson Wilson died in 1914 during her husband's first term in office. The President brought her to Rome for burial. The merchants placed black and white bunting on their businesses all along Broad Street. This picture shows the crowd awaiting the funeral procession on Broad Street.

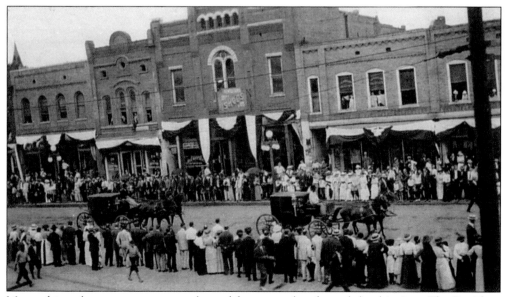

Motor-driven hearses were commonly used for upper-class funerals by this time. The President requested that Mrs. Wilson be given an ordinary person's procession. Thus horse-drawn hearses were used.

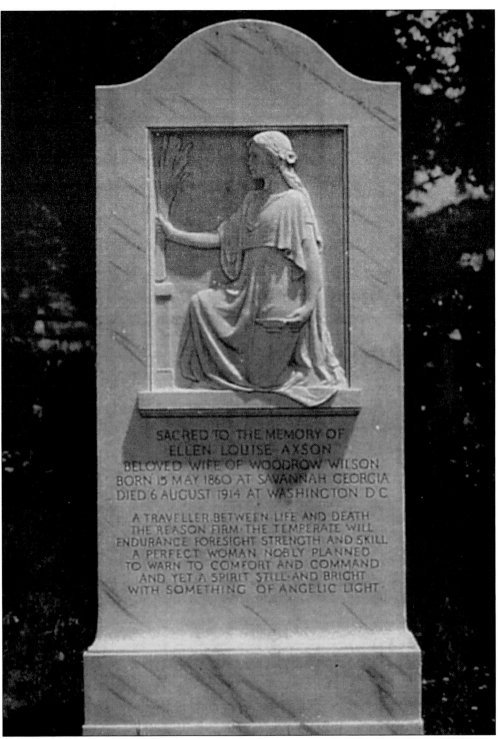

SACRED TO THE MEMORY OF
ELLEN LOUISE AXSON
BELOVED WIFE OF WOODROW WILSON
BORN 15 MAY 1860 AT SAVANNAH GEORGIA
DIED 6 AUGUST 1914 AT WASHINGTON D C

A TRAVELLER BETWEEN LIFE AND DEATH
THE REASON FIRM THE TEMPERATE WILL
ENDURANCE FORESIGHT STRENGTH AND SKILL
A PERFECT WOMAN NOBLY PLANNED
TO WARN TO COMFORT AND COMMAND
AND YET A SPIRIT STILL AND BRIGHT
WITH SOMETHING OF ANGELIC LIGHT

Mrs. Wilson is buried in her family's plot at Myrtle Hill cemetery. Many people visit her grave site each year, and the Rome Area History Museum has a special exhibit honoring Georgia's first First Lady.

Seven

FLOYD'S EARLY MEDICAL PROFESSION

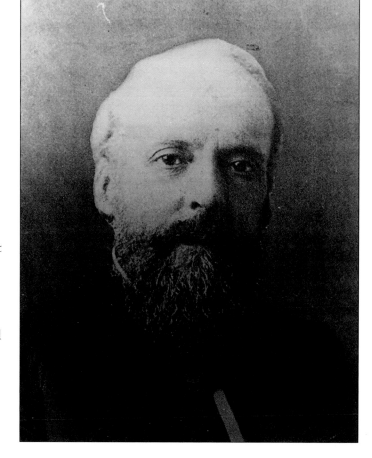

Dr. Robert Battey came to Rome in 1857. He performed the world's first bilateral oophorectomy for therapeutic reasons in 1869. Dr. Battey became known as Rome's greatest surgeon and a nationally known medical authority. He devised a new method of treating club foot and was the originator of iodized phenol. A monument to him stands on the lawn of Rome's City Hall.

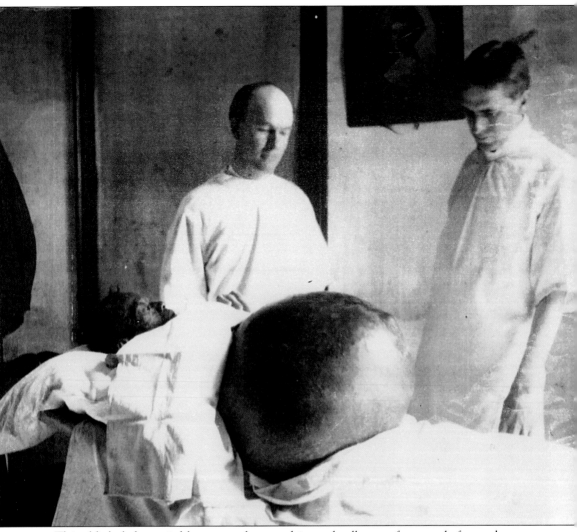

This elderly lady carried her stomach around in a wheelbarrow for years before a doctor was notified. In 1906, Dr. William P. and Dr. Robert M. Harbin successfully performed an operation removing the giant cyst. The tumor removed weighed more than the now relieved patient. The lady lived for several years following the operation.

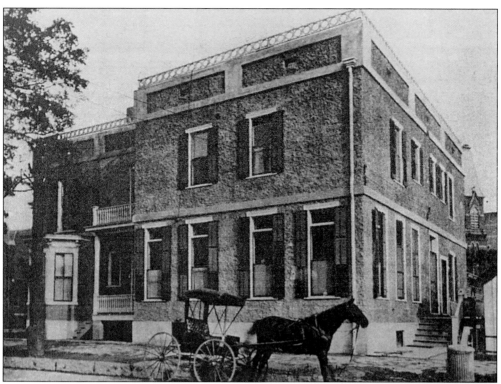

The Harbin Hospital was established in 1908. The hospital had 12 beds. In 1917, a new 40-bed, four-story hospital was constructed on Maiden Lane, and the original building was converted into a nurse's dormitory.

In 1920, additional levels were added to the Harbin Hospital, making it a seven-story, 75-bed facility.

Dr. John Turner McCall Sr. graduated from Emory University, and in 1904 he received his doctorate in medicine from the College of Surgeons and Physicians. He moved to Rome the same year and practiced there until his death in 1951. He was co-founder of the Frances Berrien Hospital in south Rome.

In 1926, Dr. John T. McCall Sr., Dr. J.N. Chaney, and Mrs. Claude D. Taylor, R.N. bought out other shareholders of the Frances Berrien Hospital and changed its name to McCall Hospital. The hospital was increased in size and a nurses quarters was added.

Dr. John W.W. Houser Jr., DDS received his degree in dentistry at Meharry Medical College in 1946. He practiced in Rome for 34 years. Dr. Houser was known for his pioneering efforts in providing long-term health care. He opened the first dental facility to serve the black population in the Rome area.

Dr. W.H. Lewis was an original member of the Rochester, Minnesota, Mayo Clinic team. He came to Rome in 1919 as a diagnostician at Harbin Clinic, and later was responsible in part for the building of Rome's Floyd Hospital. He proposed to the county board of commission that a county hospital be constructed, and spearheaded the effort.

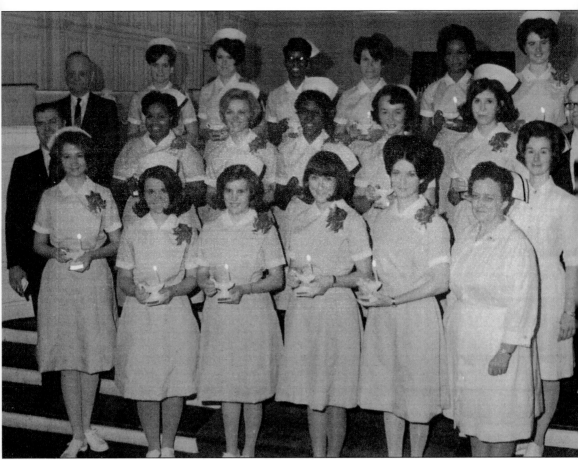

In 1966, the State Board of Nursing granted Floyd Hospital and Berry College the right to operate a three-year diploma program in nursing. Working together, Floyd Hospital and Berry College started the Floyd School of Nursing. Its first graduating class in 1969 had 12 students.

Eight
SCHOOLS AND COLLEGES

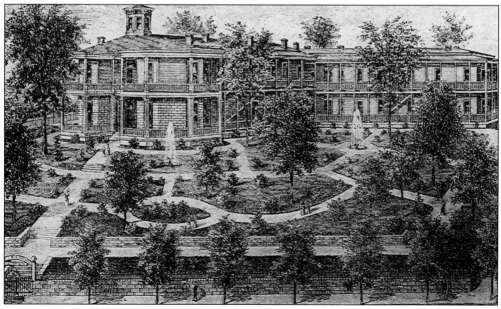

Rome Female College was the first college established in Rome. It was opened by Col. Simpson Touche and began operations in 1845. It was built on one of the three hills in Rome, Blossom Hill. The Reverend and Mrs. J.M. Caldwell succeeded Colonel Touche and ran the college until it closed in 1890. Miss Ellen Axson Wilson studied there.

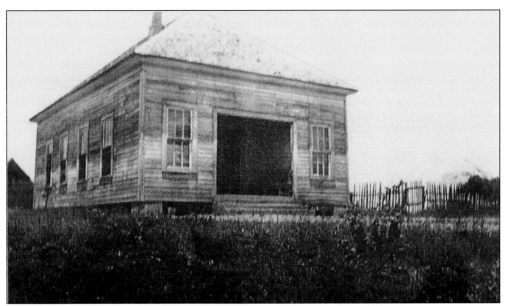

Oostanaula School was located on Bell's Ferry Road near Shannon. It was one of many wooden country schools.

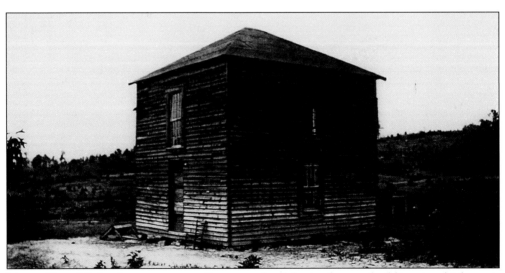

Moran Chapel School was an outstanding example of the inadequate buildings in which many country children were expected to receive an education. Those who attended these schools were often the first in their family to receive any formal education. This was a "colored only" school. Notice the outhouse in the background, which was common for this timeframe at most country schools.

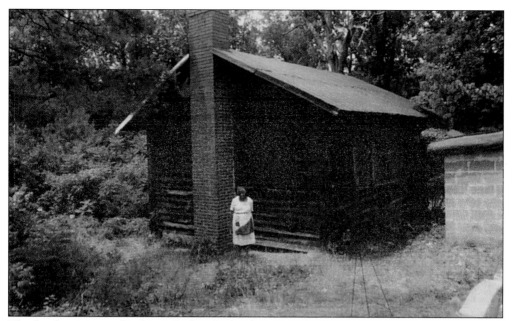

This brick structure, the Coosa "colored school," is a marked improvement over the one shown in the previous photograph. Schools within towns or densely populated communities generally were better off than their country neighbors.

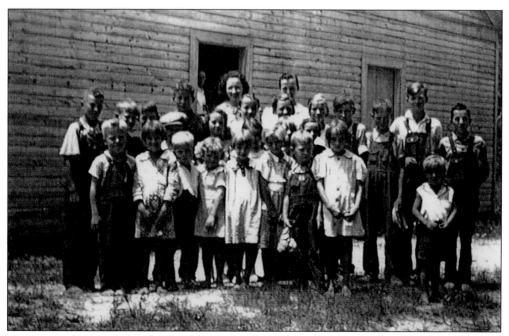

Here is another example of outlying schools. They often served more than one function. This building was a school on weekdays, and a church on Sunday and Wednesday evenings.

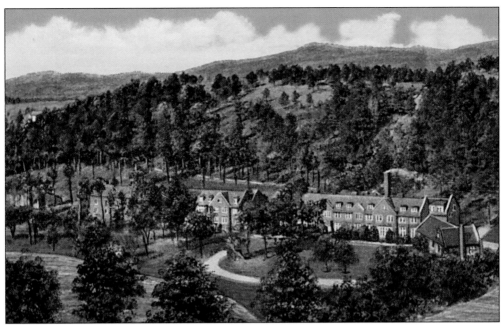

Darlington, a private school, was founded by Mr. and Mrs. J.P. Cooper in 1905. Mr. Cooper named the school after Joseph Darlington, a lifelong friend. The original goal of the school was to develop the best character in its students, with high standards of scholarship and moral training. Ernest Vandiver and Dr. C.J. Wyatt were members of Darlington's 1936 debate team.

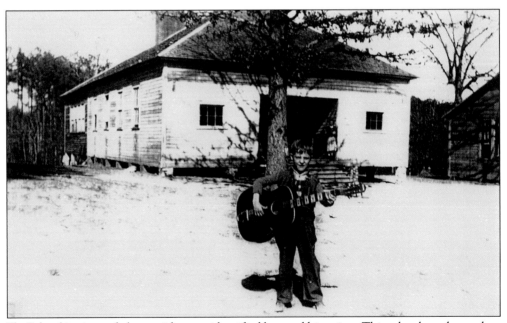

Flo School is pictured above with an unidentified boy and his guitar. This school was located on Black Bluff Road and was a large one for its time. The two structures were Flo Elementary and Flo Junior High School.

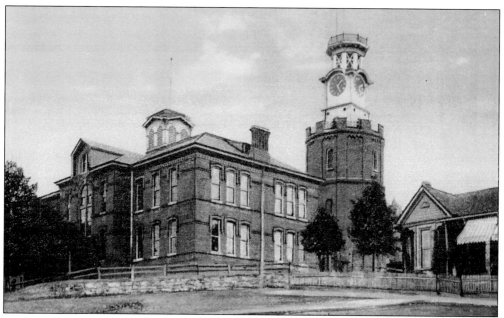

In 1883, the people of Rome passed a school bond issue, and the city council donated a lot on Lowe's Hill. This was the beginning of the Rome public school system. The construction of a building for this purpose was completed in 1884. It was originally named Tower Hill School, then changed to Central Grammar School, and once again renamed Neely School.

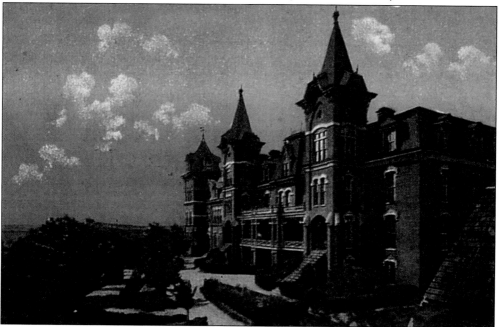

Shorter College on Maiden Lane was founded in 1873 by Alford Shorter. The following was extracted from a writing by T.J. Simmons, first president of the college: The new Shorter College will be the Vassar of the South, being the only female college in Georgia which has the use of a large endowment. Shorter offers young ladies advantages superior in every respect to those found in any competing institution.

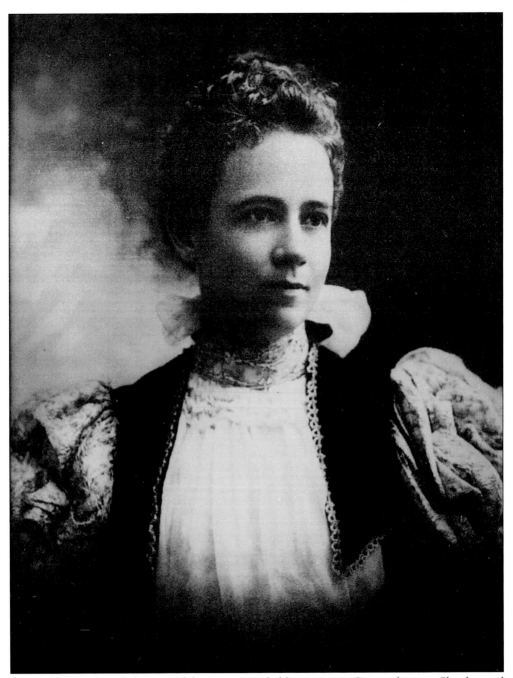

Martha Berry is regarded as one of the most remarkable women in Georgia history. She devoted her life to providing opportunity where none existed. As a young lady, she was deeply moved by the plight of rural mountain youth who had no access to schooling. She began a school in a small log cabin. From this humble beginning has risen one of the premier small colleges in America, Berry College.

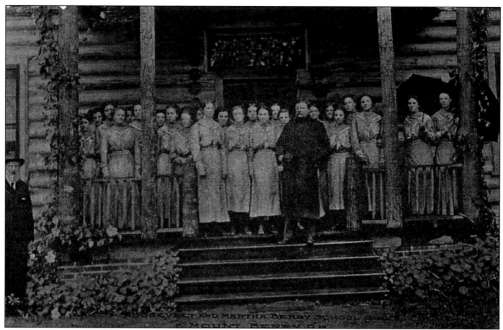

The 26th President of the United States, President Theodore Roosevelt, met Martha Berry and was impressed with her work. He wrote her suggesting that she create a girls' school. He introduced Miss Berry to Mr. and Mrs. Henry Ford. The beautiful gothic Ford buildings on campus were the result of this introduction.

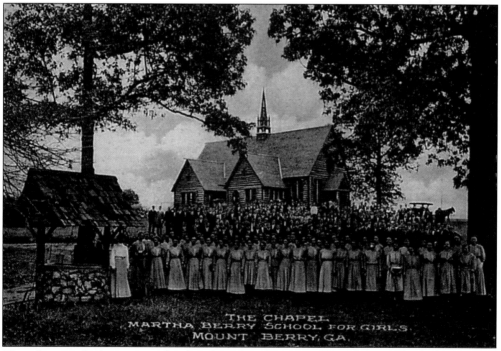

This photograph shows an early class from Miss Berry's Girls' School. The chapel is in the background. Drinking water was drawn from the well on the left.

113

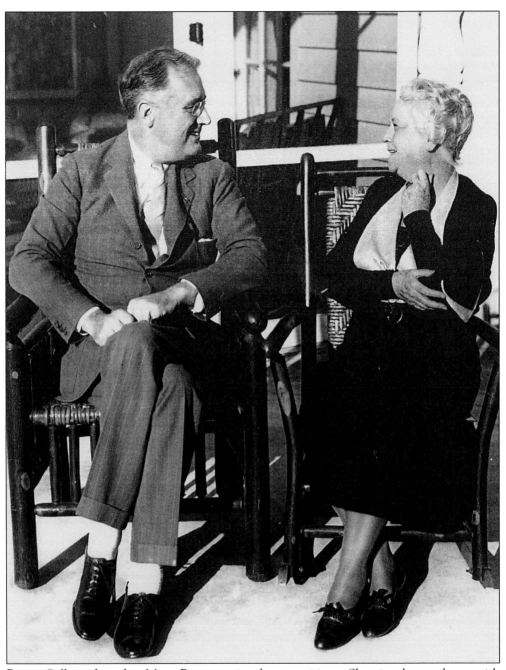

Berry College brought Miss Berry national recognition. She is shown here with President Franklin D. Roosevelt on the porch of the Little White House in Warm Springs, Georgia. Many famous people donated to help construct and maintain the college. Mrs. Thomas Edison, Amelia Earhart, Mrs. Edith (Theodore) Wilson, Dr. W.J. Kellogg, Mr. and Mrs. Henry Ford, and others were guests at Berry College and the House of Dreams.

Nine

WARS REMEMBERED

Left: The Civil War was raging in many places by 1863, but the fighting had not as yet reached Floyd County. Knowing northern Alabama and northwestern Georgia were not defended by Confederate troops, Colonel Hathaway organized over two thousand Union soldiers to invade these areas. Their mission was to destroy all factories, railroads, and telegraphs. When the enemy reached Gadsden, John Wisdom, a civilian, rode 60 miles to warn Rome. *Right:* Augustus R. Wright was a U.S. Senator from Georgia prior to the Civil War. He spoke against secession, but when Georgia left the Union he followed, and became a representative in the Confederate government. He was captured in October 1864, and agreed to act as envoy from General Sherman to President Lincoln and President Davis, in an attempt to end the war.

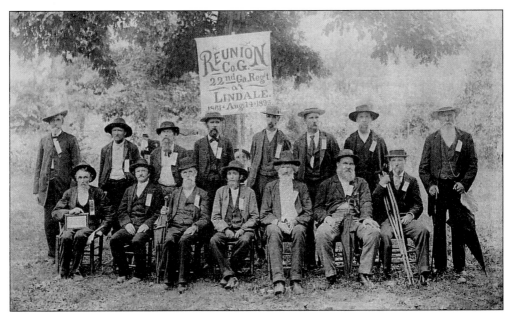

After the Civil War, many former Confederate soldiers left the South for other countries. Those who stayed suffered under the oppressive victors for many years. They never forgot the rights they fought for, and their units held reunions until death or old age prevented them from doing so. Today their descendants are determined to ensure these men and their cause are never forgotten.

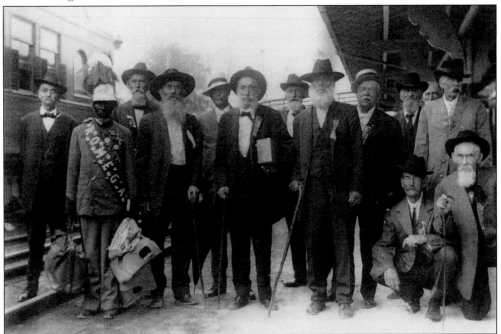

This photograph shows a Rome contingent of survivors about to board a train going to a Civil War reunion. Notice the black gentleman blending in as just one of the group. Modern day researchers have compiled a list of over 180,000 black men who fought for the Confederacy. The roll call includes date of enlistment, unit served in, battles fought in, and so forth.

The SCV erected a monument to Confederate women. The inscription reads: She was obedient to the God she adored and true to every vow she made to man. She was loyal to the country she loved so well and upon its alter laid her husband, son and sire. The home she loved to serve was graced with sincerity of life and devotion of heart.

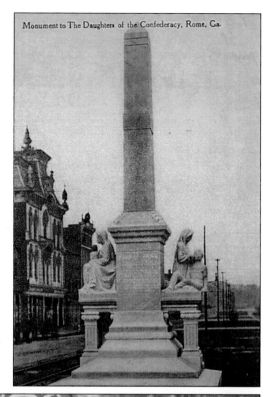

Monument to The Daughters of the Confederacy, Rome, Ga.

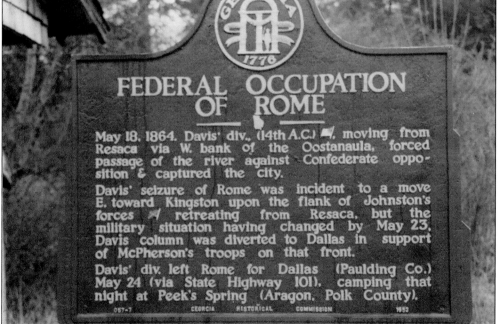

This marker shows the days in which Rome was occupied during the Civil War. It is located at the Rome Welcome Center and reads in part: May 18, 1864 Davis Division (14th AC) moved from Resaca via west bank of Oostanaula forced passage of the river against Confederate opposition and captured the city.

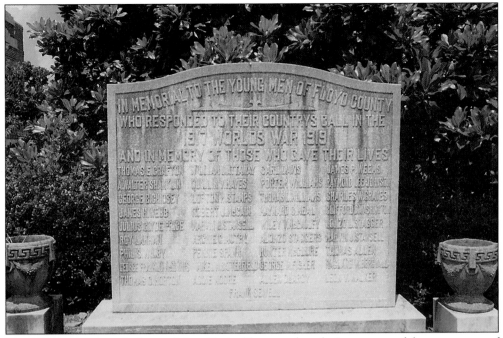

This monument is on the lawn of the old city library and reads: In memory of the young men of Floyd County who responded to their country's call in the 1917 World's War, and in memory of those who gave their lives.

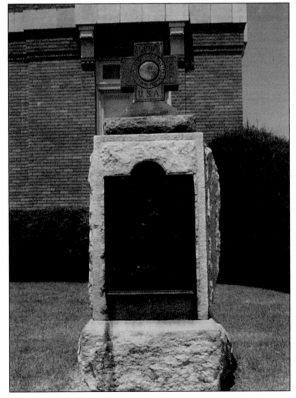

This monument in front of the city hall quotes President McKinley as follows: You have triumphed over obstacles which would have overcome men less brave and determined.

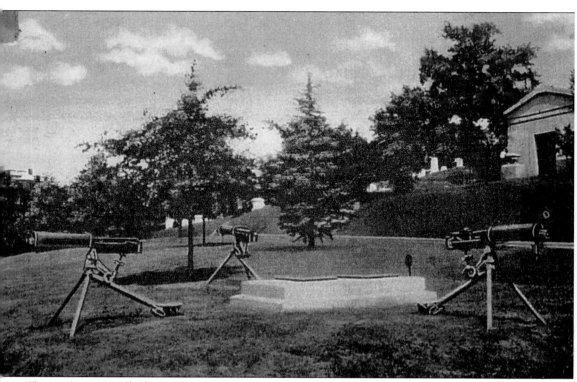

This is the grave of Charles W. Graves. The plaques read in part: Enlisted August 16, 1917 Company M-117 Infantry 3rd Tennessee Regiment 30th Division Killed on the Hindlenburg Line October 5, 1918. The last of the nation's dead to return to his native soil. This body was honored by the government of the United States of America as representative of its known dead in the World War.

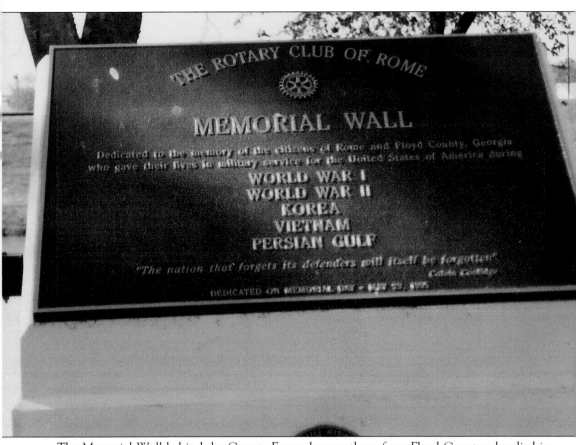

THE ROTARY CLUB OF ROME

MEMORIAL WALL

Dedicated to the memory of the citizens of Rome and Floyd County, Georgia
who gave their lives in military service for the United States of America during

WORLD WAR I
WORLD WAR II
KOREA
VIETNAM
PERSIAN GULF

"The nation that forgets its defenders will itself be forgotten".
Calvin Coolidge

DEDICATED ON MEMORIAL DAY • MAY 29, 1995

The Memorial Wall behind the County Forum honors those from Floyd County who died in WW I, WW II, the Korean War, the Vietnam War, and Desert Storm. The Vietnam Veterans Association holds a candlelight vigil in front of this monument on Memorial Day.

Ten

PLEASURE OUTINGS AND AREA MUSEUMS

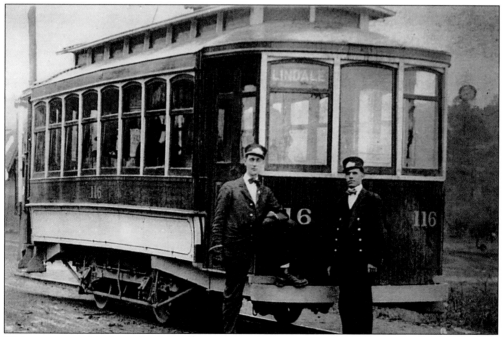

This streetcar with four wheels and two conductors was one of the earliest to make scheduled runs to Mobley (Desoto) Park. Streetcars made regular trips from Rome to Lindale, Forrestville, and Mobley Park.

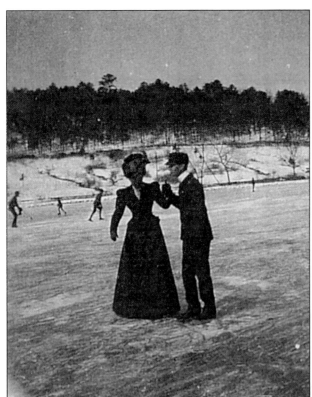

The night of February 13, 1899 saw the temperature dip to -7 degrees. Most lakes froze over with ice thick enough to walk and skate on. This photograph shows ice skaters enjoying a rare event in Floyd Country, on Mobley Lake.

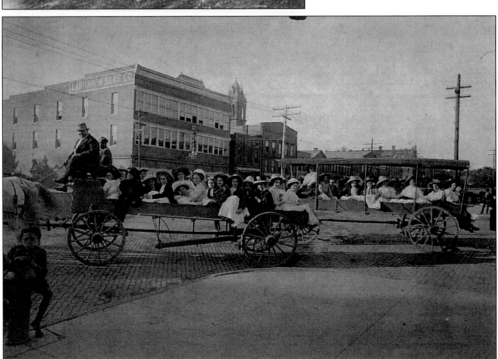

Mr. Rounsville (the driver) takes students from Shorter College on a pleasure outing through Rome in 1910.

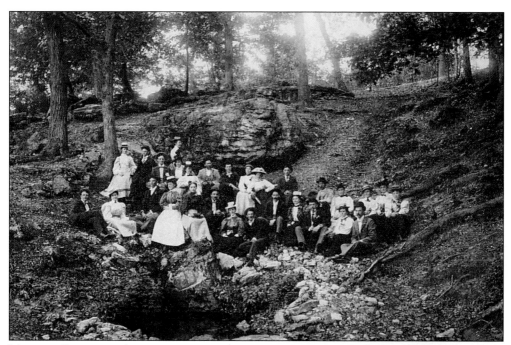

Morrison Campground
has been an area of
pleasant outings for
many years. This
photograph shows
a group of happy
picnickers in 1930.

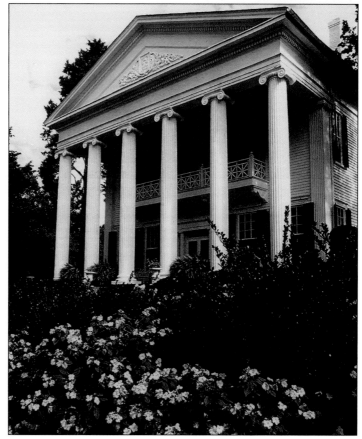

Oak Hill,
Martha Berry's family
home, is a magnificent
example of the classic
Southern antebellum
house. Constructed
in 1846, the home
remains as it was when
Miss Berry resided
there. The gardens
are its crowning glory.
Flowers are in bloom
from early spring until
frost. The Martha Berry
Museum displays a
remarkable collection
of art and memorabilia.

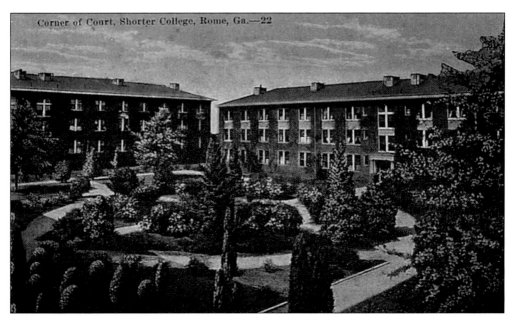

Shorter College corner court shows part of the college as it looks today. It is a liberal arts school with a religious affiliation.

The Shorter College Museum tells the story of the college from its inception in 1873 until the present. It holds the papers of the presidents and offices of the college as well as artifacts, photographs, and papers of alumni, staff, and administrators. The museum and archives are open by appointment with the director, Dr. Alice Taylor-Colbert.

124

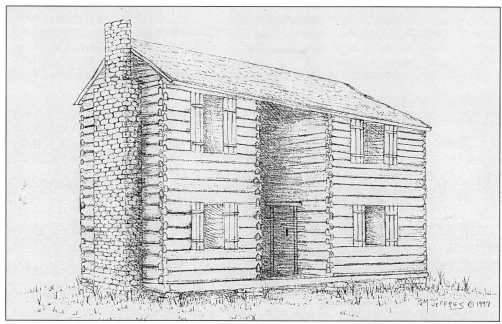

Major Ridge's home was originally a dogtrot (center hall open air front to back), log structure built in 1830. Ridge owned a ferry, store, and slaves. He struggled to adapt to the new culture which was engulfing his nation, and still retained his Cherokee heritage.

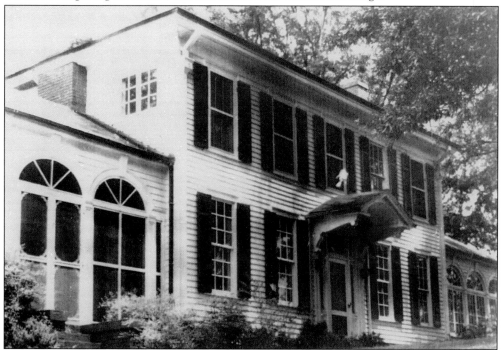

The house has been remodeled twice and is today the Chieftains Museum. It had been the home of several successful businessmen, the showplace of a cotton mill village, and was finally preserved as a museum. The original log structure is revealed today in wall sections throughout the house. The museum is listed on the National Register of Historic Places.

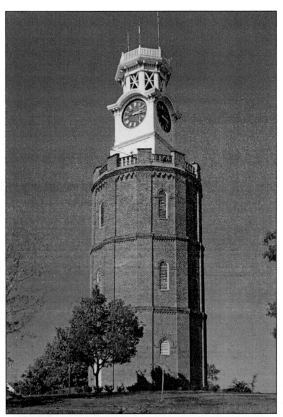

Rome's first city water tank is currently known as the Clock Tower. It has been converted into a museum. Murals depicting the history of Rome were painted on the metal walls by local artist Charles Scholtz. Climbing the 162 steps takes you to the top of the old water tank. The view of Rome and the surrounding area is breathtaking from there.

The Rome Area History Museum imparts the knowledge of Rome and the surrounding areas. It begins with a walk through time, covering local history from 1540 through the present. Mrs. Ellen Axson Wilson, the ten wars the United States has fought, a salute to education, Coca-Cola, Girl Scouts, the medical, fire, and police departments, and the Civil War are some of the special exhibits.

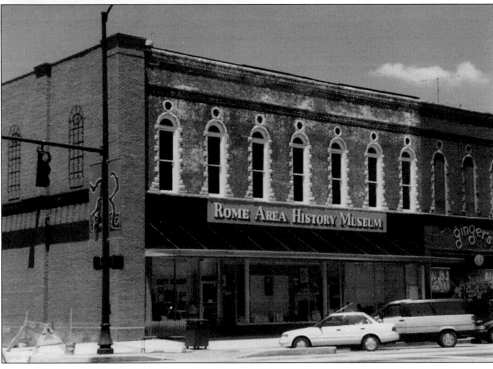

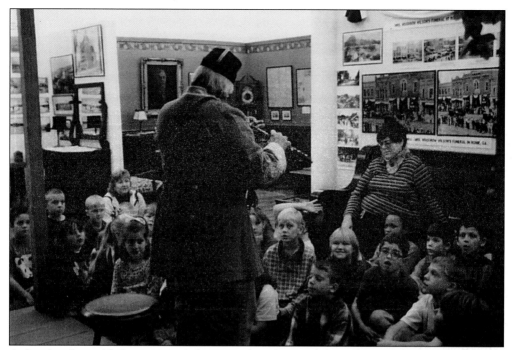

A facade of an old sharecropper's home with a front porch is the stage in the Rome Area History Museum. Granny and other storytellers use the porch to teach history in an entertaining manner. This photograph shows John Carruth relaying the history of music in the 1800s to a young audience. The porch serves many functions. Local theatrical productions are viewed here and weddings also take place.

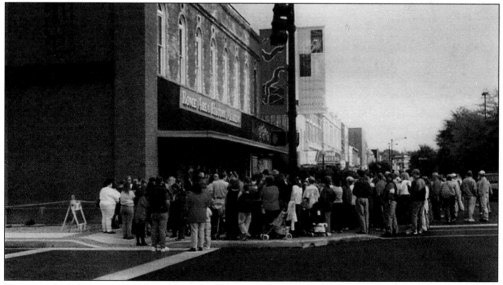

Heritage holidays are celebrated each fall in Rome. Many special events take place at this time. Choirs are positioned up and down Broad Street and the public is entertained by the music of their choice. The group shown is outside the Rome Area History Museum in 1997. A rider re-enacts the ride by John Wisdom from Gadsden to Rome. A parade and other events take place later.

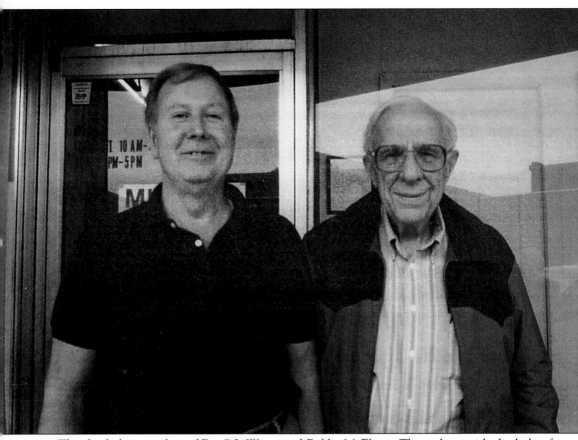

This final photograph is of Dr. C.J. Wyatt and Bobby McElwee. They, along with the help of others, established the Rome Area History Museum. The museum opened on March 31, 1996, with 4,000 square feet of display area. It is located at 303–305 Broad Street, in Rome. The five-year plan foresees expansion to 9,000 square feet of exhibit space, a theater, meeting rooms, and a special events area.